SURREALISM

SURREALISM

—

AMY
DEMPSEY

—

Thames & Hudson

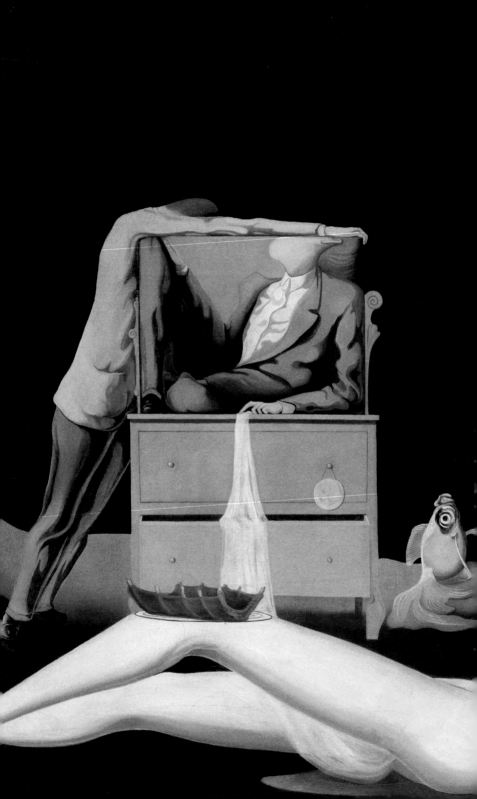

CONTENTS

INTRODUCTION

Surrealism was one of the twentieth century's most popular and pervasive art movements, affecting all branches of the arts and spreading to all corners of the globe. It arose during the Roaring Twenties, as people sought to make sense of the carnage of the First World War and tried to envision a path to a brighter, more hopeful future. The movement's founder, French poet and writer André Breton, wanted to completely transform the way people thought by learning how to mine the creative potential of the unconscious. The Surrealist Revolution aimed to free mankind from the shackles of conscious logic and reason, which had only led to war and domination.

The heyday of Surrealism, during the 1920s and 1930s, was a period of greater social and political freedoms, as well as an age of political extremism, such as the rise of Fascism, and economic upheaval, notably the Great Depression. The same desire for glamour and escapism that led to the popularity of Art Deco during the 1930s also drew the public to Surrealism.

This book will explore what Surrealism is; explain the ideas that informed the creation and development of the movement; introduce key Surrealist artists and show how the movement spread; and present some of those who exhibited under the umbrella of Surrealism. It will also look at the variety of methods used to create the artworks, the forms Surrealism took and the media used. The final chapter will look at the demise of Surrealism as an organized movement as well as its legacy.

While all of Surrealism's utopian aspirations might not have been met, this highly intellectual, poetic and radical literary and artistic movement made such a lasting worldwide impact that it continues to influence all disciplines, and the term has entered common usage as a synonym for 'bizarre' or 'fantastical'.

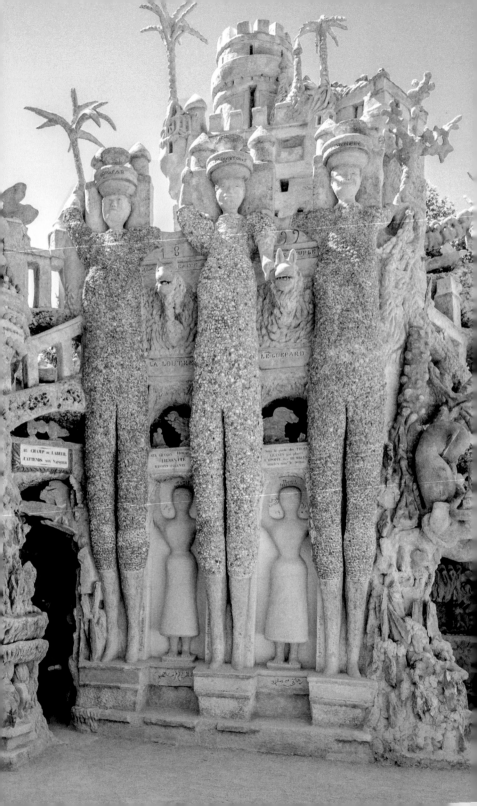

WHAT IS SURREALISM?

-

Let us not mince words: the marvellous is
always beautiful. Anything marvellous is beautiful,
in fact only the marvellous is beautiful

-

André Breton

1924

Man Ray
André Breton, 1924
Photograph
Centre Pompidou, Paris

The American photographer Man Ray, a key figure in Dada and Surrealism, met André Breton in July 1921 in Paris. This portrait of the 'Pope of Surrealism' was taken the year that the movement was launched on an unsuspecting world.

Surrealism means 'above realism' or 'more than real'. It was a literary and artistic intellectual movement launched in France by writer and poet André Breton in 1924. Although the term had been in use since 1917, when it was coined by the French critic Guillaume Apollinaire to describe something that exceeded reality, Breton successfully co-opted it to describe his own vision of the future. In the *Manifeste du surréalisme* (*Manifesto of Surrealism*, 1924), which he wrote with fellow French poets and political activists Louis Aragon and Philippe Soupault, Breton defined Surrealism 'once and for all' as:

SURREALISM, n. Psychic automatism in its pure state, by which one proposes to express – verbally, by means of the written word, or in any other manner – the actual functioning of thought. Dictated by thought, in the absence of any control exercised by reason, exempt from any aesthetic or moral concern.

Breton elaborated:

We must give thanks to Freud for his discoveries . . . The imagination is perhaps on the point of reasserting itself, of reclaiming its rights. . . I believe in the future resolution of these two states, dream and reality, which are seemingly so contradictory, into a kind of absolute reality, a *surreality*, if one may so speak. It is in quest of this surreality that I am going, certain not to find it but too unmindful of my death not to calculate to some slight degree the joys of its possession.

BRETON'S MISSION

With Surrealism Breton intended to bring about a revolution as profound as the ones by those he claimed as ideological precursors: Austrian psychoanalyst Sigmund Freud, Russian Marxist revolutionary Leon Trotsky and nineteenth-century French poets Arthur Rimbaud and Comte de Lautréamont (aka Isidore Ducasse).

Breton's model of the artist as a visionary in revolt against society was drawn from Rimbaud and Lautréamont. From Rimbaud came the call to disorder one's senses in order to reach the unknown and find something new – 'to make oneself a seer'. A phrase from Lautréamont's poetic novel *Les Chants de Maldoror* (*The Songs of Maldoror*, 1869) provided the Surrealists with their motto: 'As beautiful as the chance meeting on a dissecting table of a sewing machine and an umbrella.'

Photographer unknown
Surrealists at a fair in
Montmartre, early to mid
1920s
Bibliothèque d'Art et
d'Archéologie, Fondation
Jacques Doucet, Paris

**Surrealists pose in a
photographic set. Louis
Aragon is on the bicycle
in front and André
Breton is in the
car at the far right.**

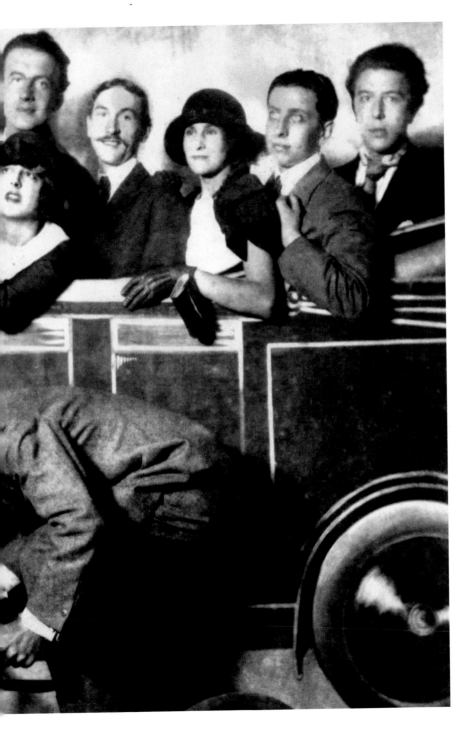

The Surrealists' motto succinctly articulated their belief that beauty, or 'the marvellous', could be found in unexpected chance encounters. In addition to his literary pursuits, Breton studied medicine and psychiatry, including the theories of Freud. In the First World War he served as a medical orderly on a ward of shell-shocked patients and was amazed by the imaginative monologues and drawings that the trauma victims produced. Breton was also an active Dadaist during the war.

An international, multidisciplinary phenomenon, Dada was as much a mindset as an art movement. It developed during and after the First World War, as young artists banded together to express their anger with the conflict. They believed that the only hope for society was to destroy those systems based on reason and logic, and replace them with ones based on anarchy, the primitive and the irrational. Through absurdist provocations, whether aggressive or irreverent, they challenged the status quo with satire, irony, games and word play.

How could the energy unleashed by Dada's disgust be transformed into something positive, life affirming and poetic?

After the war Breton became dissatisfied with Dada, its anarchism and nihilism, and wanted to find a more positive, active role for art. If Dada stood for the negation of art and the status quo, the question for Breton and others was where to go from this ground zero. How could the energy unleashed by Dada's disgust be transformed into something positive, life affirming and poetic? Breton's answer was Surrealism, which was both a continuation of Dada and a development away from it.

The Surrealists aimed for nothing less than a total transformation of the way people think. By breaking down the barriers between a person's inner and outer worlds and by changing the way they perceived reality, Surrealism would liberate the unconscious and reconcile it with the conscious. The aim was not to escape reality and live in a dreamworld but to create a new improved reality. Their mission was to overcome their disenchantment with the world, to find the marvellous in it once again.

Breton called his ally the American Man Ray a 'pre-Surrealist' and Surrealist, to describe the artist's affinity for the movement even before it had been properly formulated. Man Ray moved easily between disciplines – making paintings, sculptures, objects, films,

Man Ray
L'Enigme d'Isidore Ducasse (The Enigma of Isidore Ducasse), 1920/replica 1971
Assemblage: sewing machine, blanket, strings and wooden base, 41 x 54.3 x 22 cm (16¼ x 21½ x 8⅝ in.)
Private collection, Milan

A sewing machine was wrapped in a blanket, tied with rope and photographed. The wrapped object was purposely not identified, but left as a riddle to be figured out from its title or remain mysterious. Man Ray's photograph appeared on the first page of the inaugural issue of *La Révolution surréaliste* in December 1924.

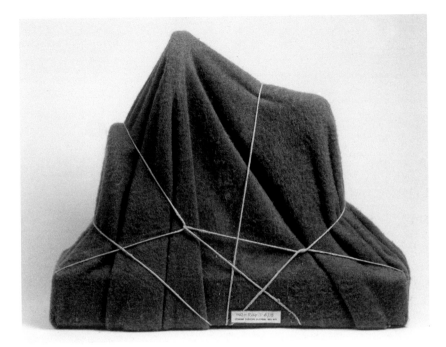

photographs and poems – and between the commercial and fine art worlds in Europe and America, greatly helping to popularize the movement. As he put it: 'My works were designed to amuse, annoy, bewilder, mystify and inspire reflection.'

Overleaf:
Giorgio de Chirico
The Soothsayer's
Recompense, 1913
Oil on canvas, 136 x 180
cm (53⅜ x 70⅞ in.)
Philadelphia Museum of
Modern Art, Philadelphia

Typical of de Chirico's
paintings are the
brooding classical statue,
the lengthening shadows,
the passing train and the
deserted city square, all
of which contribute to
the sense of loneliness
and give a disquieting air
of mystery.

INFLUENCES

Dada remained, in its techniques and its determination to break down boundaries, the Surrealists' great example. Important too were the dreamlike paintings of the Metaphysical painter Giorgio de Chirico. In *Dictionnaire abrégé du surréalisme* (*Abridged Dictionary of Surrealism*, 1938), edited by Breton with fellow French Surrealist and poet Paul Éluard, de Chirico is called a 'pre-Surrealist'. The Metaphysical painters believed in art as prophecy and in the artist as the poet-seer who, in 'clear-sighted' moments, could remove the mask of appearances to reveal the 'true reality' hidden beneath. They were fascinated by the eeriness of everyday life and aimed to create an atmosphere that captured the extraordinariness of the ordinary. Romantic and Symbolist writers and artists were also

claimed as ancestors of Surrealism, although the Surrealists believed that beauty could just as easily be found in chance encounters in the street as in the imagination. Surrealists also admired the energy and directness they saw in the tribal artefacts of so-called 'primitive cultures', especially those of North America and Oceania, and the spontaneous visions of children, visionaries, mediums, untutored artists and the insane. These untrained artists were admired for their sincerity and perseverance, and presented a seductive model of the artist as one who is compelled to create – the notion of art-making as necessity, not choice.

The most important intellectual influence on the Surrealists was Sigmund Freud, who believed that analysing dreams could help us understand our unconscious minds and release repressed memories and desires in order to cure neuroses. While Freud explored the unconscious and dreams for therapeutic ends, the Surrealists were captivated by the concept of the unconscious as the seat of the imagination and by Freudian techniques as a route to access a treasure trove of buried images to exploit at will. In particular, they were interested in Freud's ideas about castration anxiety, fetishes and the 'uncanny' and how they manifested themselves symbolically in one's dreams.

-

Accompanying this dark, discomfiting strain, there is also an emphasis on game playing and experimentation

-

Most Surrealist work addresses such disquieting drives as fear, desire, obsessive love, violence, death and eroticization. Accompanying this dark, discomfiting strain, there is also an emphasis on game playing and experimentation, of breaking through ideas of what adults do and children do, an embrace of collaboration and an appreciation of the absurd. There is often a combination of attraction and repulsion in the imagery.

BRETON'S VISION

Breton believed that by uniting dream and reality, mankind could harness the forces of the unconscious. But how was one to suspend conscious control to reach the unconscious? Early experiments with drugs, séances and hypnotic trances to get to the unconscious were soon abandoned as too dangerous, physically and psychically. Instead the Surrealists turned to Freudian dream analysis for the

Oscar Domínguez
Freud. Mage de rêve –
Etoile (Freud. Magician of
Dreams – Star), 1941
Playing card from 'Le Jeu
de Marseille', 1940–41
Pencil drawing, ink and
gouache, 27.1 x 17 cm
(10¾ x 6¾ in.)
Musée Cantini, Marseille

In 1940 Breton and a group of his Surrealist friends collectively designed a set of playing cards that would reflect their heroes and beliefs. Spanish artist Domínguez designed the Sigmund Freud card (see page 95).

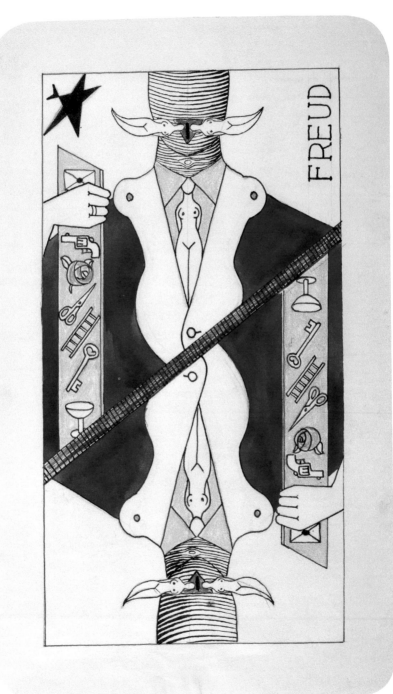

hidden images that were revealed and to free association for its stream-of-consciousness unexpected juxtapositions. Freud's theory of the 'uncanny' (elaborated in 1919) posits that when one experiences something as eerily familiar, the familiar thing looks strange because it has been repressed and that this is experienced as discomfort or shock by the recipient. In the same essay, Freud also writes that in 'dreams, phantasies and myths . . . the fear of going blind is often enough a substitute for the dread of being castrated'. Freud's concept of the fetish is that of a refusal of sexual difference, of a substitution of the unnatural for the natural.

The Surrealists drew on these ideas in a variety of ways: in their attempts to make the familiar unfamiliar; in their experiments with automatic writing and drawing; in their use of chance and strange juxtapositions; in their notion of the devouring female; and in the breaking down of boundaries – between genders, between man and animal, and between fantasy and reality. Interpretation of these works does not stop at the retina – the corporeality of vision is asserted, as the eye is reinstated as a part of the body, subject to such drives as fear, desire and erotization.

Max Ernst
The Blind Swimmer, 1934
Oil and graphite on canvas, 92.3 x 73.5 cm
(36⅜ x 29 in.)
Museum of Modern Art
(MoMA), New York

Ernst, whom Breton described as having 'the most magnificently haunted brain', was one of the most inventive and prolific of the Surrealists. He said: 'I believe the best thing to do is to have one eye closed and to look inside, and this is the inner eye. With the other eye, you have it fixed on reality, what is going on around you in the world.'

But while the image looks like an eye amid a stream, it also seems to depict the female sexual organs

By looking at a painting by German artist Max Ernst, a key Surrealist, we can see some of these ideas and techniques at play. *The Blind Swimmer* (1934; opposite), one of his most abstract paintings, has a dreamlike quality reminiscent of the 'uncanny' of Rimbaud and Freud. What is it about? It can be interpreted – like a dream – in a number of different ways. The title is unsettling, evoking a nightmare of helplessness. But while the image looks like an eye amid a stream, it also seems to depict the female sexual organs. Now the title brings to mind sperm swimming towards the egg. Yet again, the image could represent the *male* sexual organ. Or perhaps it is an eye after all, reflecting what is seen in the pupil: an insect, a flower or a vulva threatening castration.

This ambiguity, the play between the title and image, the love of visual and verbal puns, is characteristic of much Surrealist work. The themes of procreation, germination, blindness and castration were addressed by Ernst in an essay in 1936: 'Blind swimmer, I have made myself see. *I have seen*. And I was surprised and enamoured of what I *saw*, wishing to identify myself with it.' This gender oscillation

and confusion of sexual difference by combining male and female in the same entity is a common strategy in Surrealist imagery.

BRETON'S DREAM

In sharp contrast to the chaos and spontaneity of Dada from which it sprang, Surrealism under Breton was a highly organized movement with doctrinaire theories. In fact, Breton revolutionized art criticism:

21

from now on, the critic as charismatic leader of an avant-garde group would be a familiar figure. In 1924 Breton's *Manifesto of Surrealism* was published, a Bureau of Surrealist Research was established by French poet Antonin Artaud to collect and discuss examples of Surrealism, and a magazine was launched to publish their findings – *La Révolution surréaliste*, with the first issue calling for a 'new Declaration of the Rights of Man'.

A whole array of characters were brought into the pantheon of honorary Surrealists over time

Breton's commitment to Surrealism was all-consuming. He championed an inclusive, international model, in which Surrealism had the atmosphere of a community of individuals, past and present, with converging interests. A whole array of characters were brought into the pantheon of honorary Surrealists over time or admired as kindred spirits. One of these was Hélène Smith, a famous late-nineteenth century Swiss medium, whose trance visions resulted in automatic writing and paintings of 'life on Mars'. Smith was admired by the Surrealists, particularly Breton, who based the central character of his 1928 novel, *Nadja*, on her. Breton also included Smith in the *Dictionnaire abrégé du surréalisme* (1938).

Sir John Tenniel
Illustration for Lewis Carroll's *Alice's Adventures in Wonderland* (1856) in *The Nursery Alice*, 1890
British Library, London

Carroll was considered one of the patrons of Surrealism and the British Surrealists were dubbed 'the Children of Alice'.

Hélène Smith
Paysage martienne (Martian Landscape), c.1900
Gouache on paper, 21.1 x 25.6 cm (8⅜ x 10⅛ in.)
Bibliothèque de Genève, Geneva

This is one of Smith's paintings based on a vision she saw while in a trance. Another one of her drawings of life on Mars, *Interieur ultramartien* (1899), was reproduced in the Surrealist issue of the Belgian periodical *Variétés* in 1929.

THE NURSERY "ALICE."

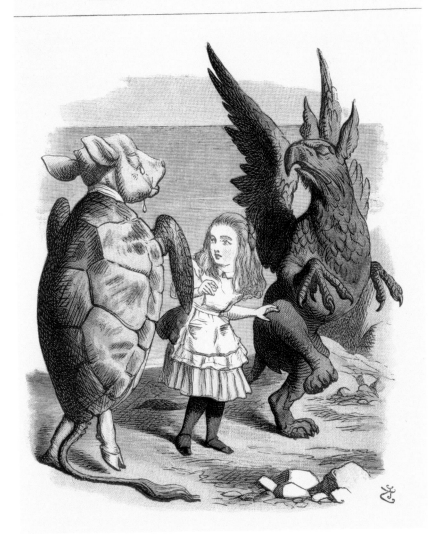

Another important nineteenth-century figure was British writer Lewis Carroll. The Surrealists shared with Carroll an appreciation for the unexpected, his interest in dreams, madness and unconscious thought, and a desire to create an alternative reality. Carroll is also included as an entry in the *Dictionnaire abrégé du surréalisme*, as is his fictional animal species, Snark, from his nonsense poem 'The Hunting of the Snark' (1876).

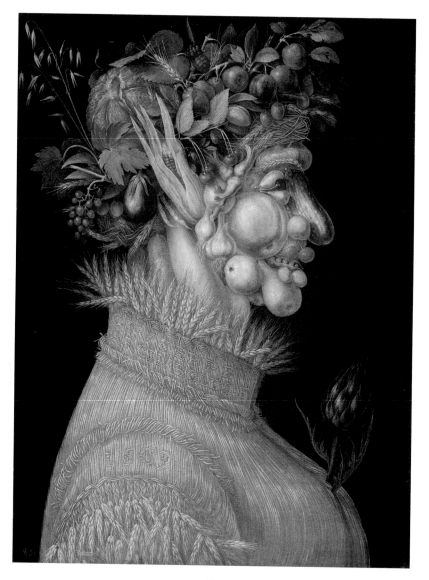

Giuseppe Arcimboldo
Summer, 1572
Oil on panel, 67 x 50.8 cm
(26½ x 20 in.)
Kunsthistorisches Museum,
Vienna

Arcimboldo's weird and
wonderful composite
images of people assembled
from fruit, vegetables,
trees, fish and bread
appealed to the Surrealists.

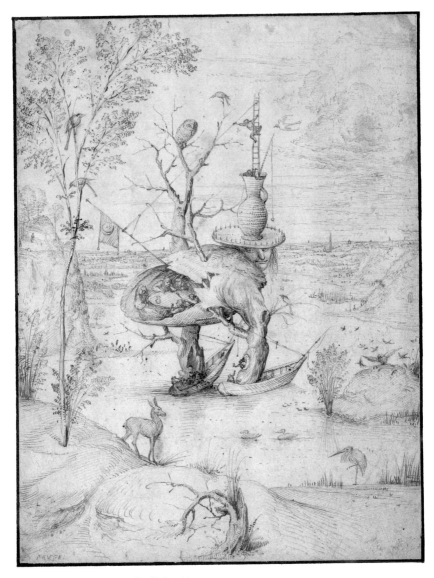

Hieronymus Bosch
Tree Man, c.1505
Pen and brown ink on paper,
27.7 x 21.1 cm (11 x 8⅜ in.)
Albertina Museum, Vienna

Bosch's feverish,
apocalyptic dreamlike
panoramas full of
fantastical hybrid
creatures were admired
by the Surrealists.

Le Facteur Cheval
Le Palais Idéal, 1879–1912
Hauterives, France

Cheval collected oddly
shaped stones, fossils
and shells on his postal
rounds. Working at night,
he fashioned his massive
structure by building a
skeleton of wire, covering
it with a mixture of wet
cement and lime, and
pressing his treasures into
it. Despite the ridicule
of his neighbours (who
thought him an 'old fool',
but not dangerous nor his
condition contagious),
Cheval's Palais Idéal
became a tourist
attraction in his lifetime.

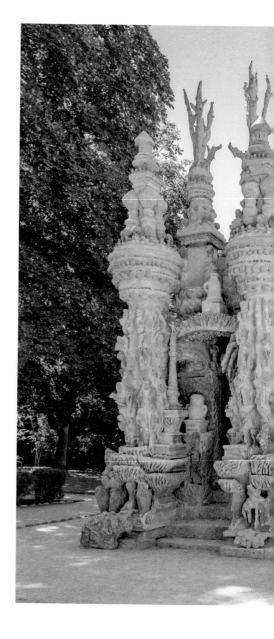

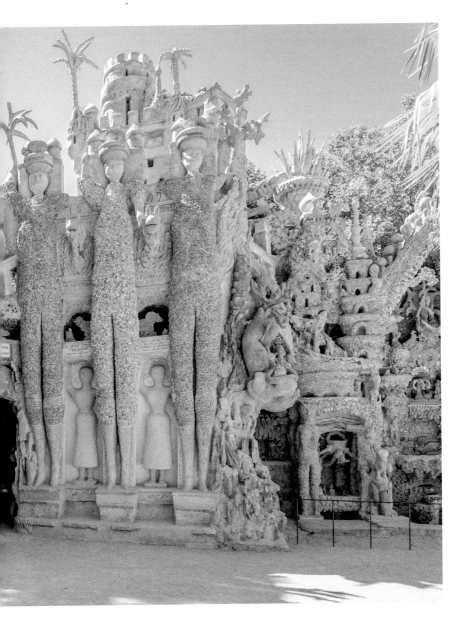

WHO WERE THE SURREALISTS?

-

**Surrealism belongs not to any nation,
but to humanity itself**

-

Surrealist Group in England

1936

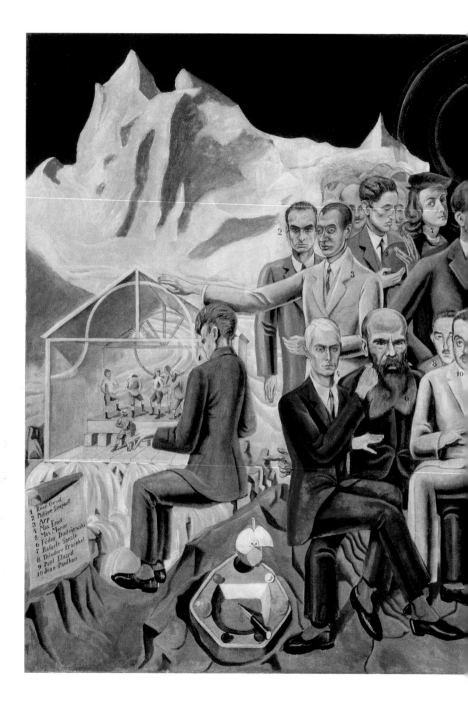

1 René Crevel
2 Philippe Soupault
3 Arp
4 Max Ernst
5 Fédor Morise
6 Raforle Sanzio
7 Théodore Fraenkel
8 Paul Eluard
9 Jean Paulhan
10

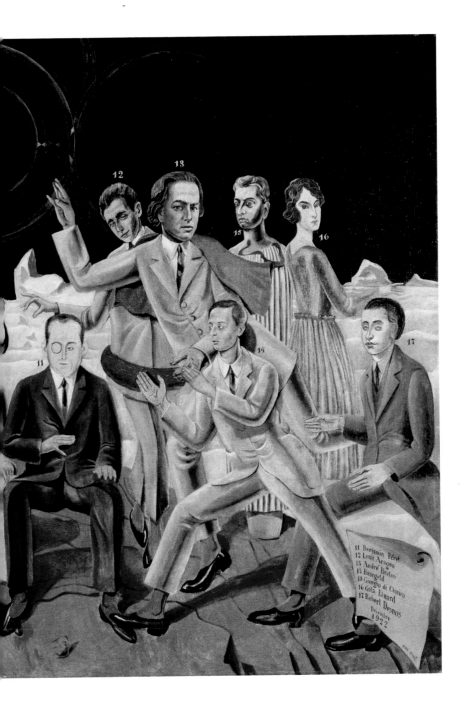

Surrealism was enormously appealing to artists. Many of the original Surrealists were drawn from the ranks of Dada, such as German Max Ernst, American Man Ray and German–French Jean (Hans) Arp. New members to join immediately included French Antonin Artaud, André Masson, Yves Tanguy and Pierre Roy, and Spanish Joan Miró. Later, through the 1920s and 1930s, new members continued to join, including Romanians Tristan Tzara and Victor Brauner; Austrian Wolfgang Paalen; Spanish Salvador Dalí, Luis Buñuel and Oscar Domínguez; Swiss Alberto Giacometti; Chilean Roberto Matta; Cuban Wifredo Lam and Germans Hans Bellmer and Richard Oelze. Other artists stayed on the fringes of Surrealism, such as Belgian René Magritte. Still others were claimed for Surrealism, whether they liked it or not, such as Italian Georgio de Chirico; Spanish Pablo Picasso; Russian Marc Chagall; Swiss Paul Klee and French Marcel Duchamp and Francis Picabia.

-

Picasso joked that if a bracelet could be covered in fur, then perhaps anything could be

-

Despite the misogyny implicit in much Surrealist philosophy and work, there were a number of female Surrealists, notably Argentine Leonor Fini; British Leonora Carrington and Eileen Agar; French Valentine Hugo, Jacqueline Lamba Breton, Dora Maar and Claude Cahun; Americans Dorothea Tanning, Kay Sage and Lee Miller; Spanish Remedios Varo; Czech Toyen and Swiss Meret Oppenheim.

Oppenheim joined the Surrealists in 1932. In 1936 the 22-year-old pitched the idea of a bracelet covered in fur to Paris-based Italian fashion designer Elsa Schiaparelli. The designer went for it and ended up including the bracelet in her Winter Collection. Oppenheim was wearing the bracelet when she met Pablo Picasso and Dora Maar for lunch one day at Café de Flore in Paris. Picasso joked that if a bracelet could be covered in fur, then perhaps anything could be, to which Oppenheim replied: 'Even this cup and saucer. Waiter, a little more fur!' Oppenheim promptly went out and bought a cup, saucer and spoon, wrapped them in speckled tan fur and entitled the assemblage *Object*.

This lunchtime banter was the spark for what became one of the most famous Surrealist works of art. The piece caused a sensation when it debuted in the 'Exposition surréaliste d'objets' at the Galerie Charles Ratton in Paris in May 1936. It then went on tour, shocking and delighting audiences in London at the

Previous page: Max Ernst
Au rendez-vous des amis,
1922
Oil on canvas, 130 x 193
cm (51¼ x 76⅞ in.)
Museum Ludwig, Cologne

André Breton (number 13, wearing a red cape) – nicknamed the 'Pope of Surrealism' – gives his blessing to the poets and artists of the emerging movement assembled in a strange, mountainous landscape. Front row, from left to right: René Crevel, Max Ernst (number 4, sitting on Dostoyevsky's knee), Theodor Fraenkel, Jean Paulhan, Benjamin Péret, Johannes Theodor Baargeld, Robert Desnos. Back row: Philippe Soupault, Hans Arp, Max Morise, Raffaele Sanzio, Paul Éluard, Louis Aragon (with laurel wreath around his hips), André Breton, Giorgio de Chirico and Gala Éluard.

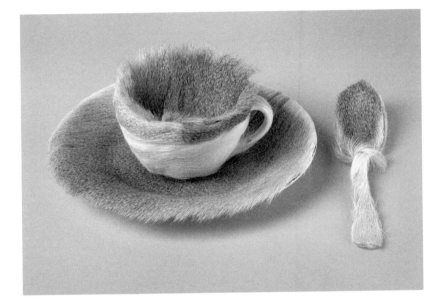

Meret Oppenheim
Object (Le dejeuner en fourrure) (The Luncheon in Fur), 1936
Cup 10.9 cm (4⅜ in.) in diameter; saucer 23.7 cm (9⅜ in.) in diameter; spoon 20.2 cm (8 in.) long, overall height 7.3 cm (2⅞ in.)
Museum of Modern Art (MoMA), New York

Oppenheim's fur-covered cup, saucer and spoon is now one of the most readily recognized Surrealist objects. It was the first work of art by a female artist purchased by the Museum of Modern Art in New York for its permanent collection, in 1946.

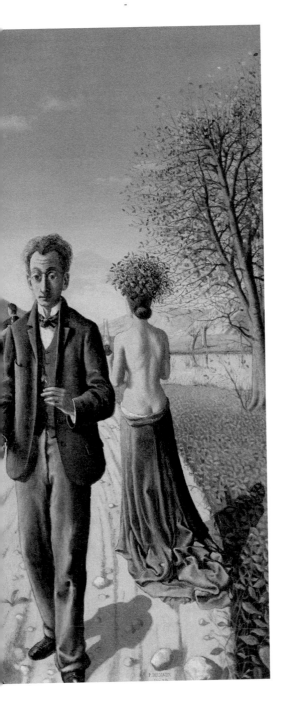

Paul Delvaux
Le chemin de la ville
(*The Path to the City*),
1939
Oil on canvas,
110.5 x 129.5 cm
(43½ x 51 in.)
Yale University Art
Gallery, New Haven

**Delvaux is known for
his paintings of scenes
peopled by sleepwalking
nudes. Reflecting later,
he remarked: 'For me
Surrealism represents
freedom and as
such was extremely
important to me. One
day I was granted the
freedom to transgress
rationalist logic.'**

'International Surrealist Exhibition' and in New York at the Museum of Modern Art's blockbuster 'Fantastic Art, Dada, Surrealism' exhibition. The improbability of a fur-lined tea set, and the horrible feeling that it conjures up in your mouth if you imagine drinking from it, captured the public's imagination and made Oppenheim's name.

Breton promoted his conception of Surrealism and those artists he admired through manifestos, magazines, books, lectures, exhibitions and festivals. In 1925 the first Surrealist group exhibition – 'Exposition, la peinture surréaliste' – was held at the Galerie Pierre in Paris, with works by Arp, Ernst, de Chirico, Masson, Miró, Picasso, Man Ray and Roy. The same year Breton and Paul Éluard visited Brussels, to make contact with avant-garde artists living in Belgium.

'Le Surréalisme en 1929', *Variétés*, Bruxelles, June 1929

This special Surrealist issue surveyed the state of Surrealism in 1929. The object on the cover is known as 'The Tabernacle' and was supposedly found by Yves Tanguy in a flea market. It was later reproduced in the *Dictionnaire abrégé du surréalisme* of 1938 as the quintessential example of a 'found object'.

-
Magritte's techniques translate everyday objects into images of mystery
-

The following year an independent Surrealist group was formed in Brussels. Members Paul Delvaux and René Magritte were also known as Magic Realists for their blending of realistic imagery and magical content. Like the Surrealists, they used free association to create a sense of wonder in everyday subjects, but they rejected Freudian dream imagery and automatism. Delvaux's paintings typically feature nude women in strange scenes, their hypnotic trance-like state suggesting the fantasies of dreams or fairytales, provoking in the viewer a voyeuristic sense of being allowed special access to them (see previous page).

Magritte, the most famous of the Magic Realists, is known for his painstakingly realistic 'fantasies of the commonplace'. His pictures raise questions about the reality of representation, set up oppositions between real space and fictive space, and challenge the concept of a painting as a window on the world. His techniques – incongruous juxtapositions, paintings within paintings, combinations of the erotic and the ordinary, and disruptions of scale and perspective – translate everyday objects into images of mystery. Other prominent Belgian Surrealists included photographers Paul Nougé and Raoul Ubac, and artist and gallery owner E. L. T. Mesens.

In 1926 the Galerie Surréaliste opened in Paris with an exhibition of work by Man Ray and Oceanic objects owned by Surrealists. In 1928 Breton published *Surrealism and Painting*, a book illustrated with works by Picasso. In June 1929 Belgian journal *Variétés*

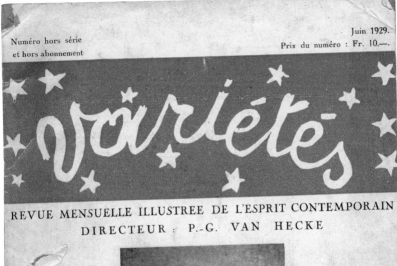

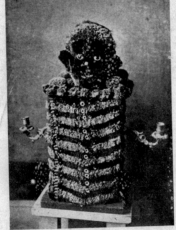

published a special issue on the state of Surrealism. It featured
a found object on the cover, an essay by Freud on 'Humour',
poems and essays by Parisian and Belgian Surrealists, illustrations
of 'Exquisite Corpse' collaborations (see page 95) and Surrealist
artwork by Arp, Ernst, Tanguy and Man Ray, as well as Belgians
Mesens, Nougé and Magritte, among others. The 1920s came
to a close with the publication of Breton's 'Second Manifeste
du surréalisme' in the final issue of La Révolution surréaliste in
December 1929. The issue included a survey on love, opening
with the question: 'What kind of hope do you put in love?'

Magritte's answer, 'All I know of the hope I place in love, it's that
it is up to a woman to give it reality', was accompanied by Je ne vois
pas la femme cachée dans la forêt (I Do Not See the Woman Hidden

René Magritte
*Je ne vois pas la femme
cachée dans la forêt*, 1929
Photomontage, published
in *La Révolution surréaliste*,
no. 12, 15 December
1929, Paris, page 73

**Top row: Breton is in the
centre with Aragon on
his left and Buñuel on
his right. Second row:
Dalí is on the left and
Éluard on the right. Third
row: Ernst is on the left.
Fourth row: Magritte is
on the right. Bottom row:
Nougé is on the left and
Tanguy is in the centre.**

André Breton
'Second Manifeste du
surréalisme' (Second
Manifesto of Surrealism),
published in *La Révolution
surréaliste*, no. 12, 15
December 1929, Paris,
pages 1–17

**André Breton stated in
his 'Second Manifesto of
Surrealism': 'The problem
of social action, I would
like to repeat and to
stress this point, is only
one of the forms of a
more general problem
which Surrealism set
out to deal with, and
that is the problem of
human expression in all
its forms.'**

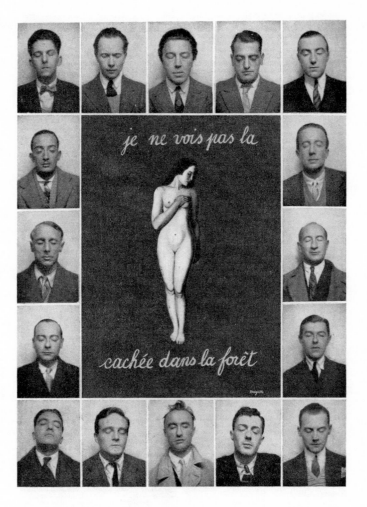

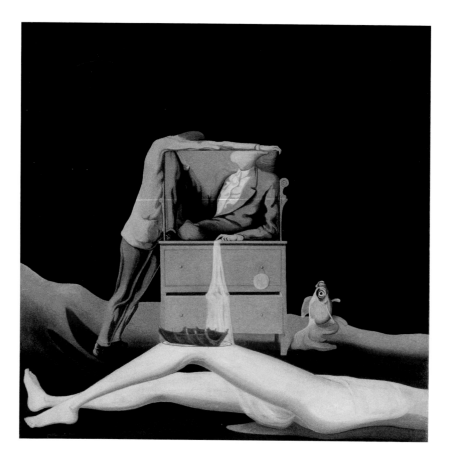

in the Forest, 1929), a photoreproduction of a photomontage made from a photograph of his 1929 painting of a nude woman, *La Femme cachée* (*The Hidden Woman*), surrounded by photo-booth portraits of sixteen male Surrealists with their eyes closed (see previous page). The first automatic photo booth was patented in New York City in 1925. It was an immediate success and the first one was installed in Paris in 1928. Breton and his Surrealist friends loved the portraits they produced.

The result is a potent image of the central, complicated role of the female in Surrealism as well as a portrayal of the importance of dreams and the unconscious. It also neatly highlights the close ties between Breton's Paris Surrealists and the newly formed Brussels group, of which Magritte was a member.

Wilhelm Freddie
Les Tentations de Saint Antoine (*The Temptations of St Anthony*), 1939
Oil on canvas, 87.5 x 88 cm (34½ x 34¾ in.)
Centre Pompidou, Paris

In Freddie's painting, a modern-day St Anthony is desperately trying to resist the temptations of the flesh dangled tantalizingly in front of him by the devilish character on the dressing table.

Surrealism was also introduced to Scandinavia in 1929, with Danish artists Vilhelm Bjerke-Petersen and Wilhelm Freddie spearheading the movement in Denmark and the Halmstadgruppen (Halmstad Group) doing the same in Sweden. Freddie is the most famous Danish Surrealist. He learned about the movement from *La Révolution surréaliste*, and along with Bjerke-Petersen, organized 'Kubisme-Surrealisme' in Copenhagen in 1935 and participated in the international Surrealist exhibitions in 1936 (London) and 1947 (Paris). Freddie declared: 'Surrealism is neither a style nor a philosophy. It is a permanent state of mind.' His uncompromising visceral images of the 1930s typically address his fascination with eroticism as well as his concerns over the growing threat of war. He was imprisoned in Copenhagen for ten days in 1937 for exhibiting work that was deemed obscene in his exhibition 'Pull the Fork out of the Eye of the Butterfly. Sex Surreal'. Other Danish Surrealists of the 1930s and 1940s included Henry Heerup, Rita Kernn-Larsen and Elsa Thoresen.

Halmstad is a small coastal town in Sweden where six artists, brothers Axel Olson and Erik Olson, their cousin Waldemar

Stellan Mörner
Drömland med hjärta
(Dreamland with Hearts),
1939
Oil on canvas, 73 x 81 cm
(28¾ x 32 in.)
Halmstad Municipality,
Halmstad

Mörner painted a series of dreamscapes like this one in the late 1930s that seem to draw on memories from his childhood spent in the family's stately home.

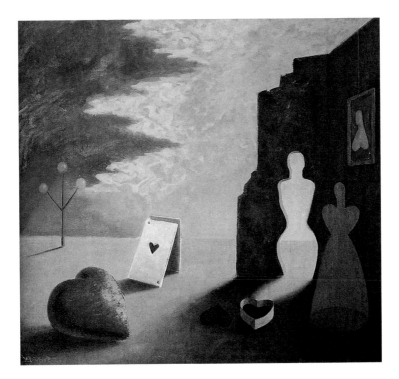

Jindřich Štyrský
From My Diary, 1933
Oil on canvas, 135 x
205 cm (53¼ x 80¾ in.)
Trade Fair Palace,
National Gallery of
Prague, Prague

**For Štyrský 'sleep is a
bee that gathers honey
for reminiscence to
savour . . . We have no
reminiscences, but we try
to construct them.'**

Lorentzon and friends Sven Jonson, Stellan Mörner and Esaias Thorén joined together to fight the resistance to modern art in Sweden. By the mid-1930s they were a fully formed Surrealist group with ties to other European Surrealist groups. Their work is known for its distinctive Nordic light and focus on the local landscape. The Halmstad Group exhibited in 'Kubisme-Surrealisme' in Copenhagen in 1935 and in the international Surrealist exhibitions in 1936 (London) and 1938 (Paris). The group only dissolved in 1979 when Mörner died.

Toyen
Deserted Den, 1937
Oil on canvas,
113 x 77.5 cm
(44½ x 30⅜ in.)
State Gallery of Art, Cheb

For Breton, a close friend and supporter, Toyen's work was 'as luminous as her own heart yet streaked through by dark forebodings'.

THE SPREAD OF SURREALISM

Surrealism really burst onto the international stage during the 1930s with major exhibitions in Brussels, Copenhagen, London, New York and Paris. It soon became a worldwide popular phenomenon, with groups forming in England, Czechoslovakia, Belgium, Egypt, Denmark, Japan, the Netherlands, Romania and Hungary. Breton was an important presence at many of these exhibitions, both to lend his support and to scout new recruits.

In 1931 the first large-scale exhibition of Surrealism was held in the United States at the Wadsworth Atheneum in Hartford, Connecticut, and in 1934 Belgian Surrealists Mesens and Nougé organized the first international Surrealist exhibition in Brussels, 'Minotaure', with Breton lecturing during the run of the show. A Surrealist group in Czechoslovakia was founded in Prague in 1934 and Breton visited and lectured in 1935 on the occasion of their first 'Exposition internationale du surréalisme', paying homage to its members, who included Karel Teige, Toyen and Jindřich Štyrský. Breton described his visit with Štyrský as 'one of the most beautiful memories of my life'.

Symbolically abandoning the 'corset' and the constraints of her gender, Marie Čermínová changed her name to 'Toyen'

Avant-garde artists Štyrský and Toyen worked closely together from their meeting in the early 1920s until Štyrský's death in 1942. They supported and inspired each other and in 1934 were founder-members of the Czechoslovak Surrealist group. Štyrský was a painter, poet, photographer, stage designer and graphic artist. Fascinated by Freud's psychoanalysis, he kept a dream diary that he used as source material for his paintings, poems and collages

INTERNATIONAL SURREALIST BULLETIN

No. 4
ISSUED BY THE SURREALIST GROUP IN ENGLAND
PUBLIÉ PAR LE GROUPE SURRÉALISTE EN ANGLETERRE

BULLETIN INTERNATIONAL DU SURRÉALISME

PRICE ONE SHILLING SEPTEMBER 1936

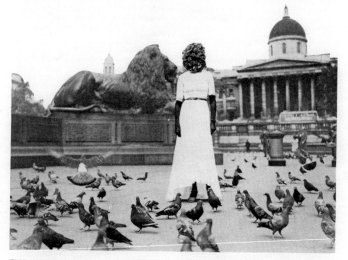

THE INTERNATIONAL SURREALIST EXHIBITION

The International Surrealist Exhibition was held in London at the New Burlington Galleries from the 11th June to 4th July 1936.

The number of the exhibits, paintings, sculpture, objects and drawings was in the neighbourhood of 390, and there were 68 exhibitors, of whom 23 were English. In all, 14 nationalities were represented.

The English organizing committee were: Hugh Sykes Davies, David Gascoyne, Humphrey Jennings, Rupert Lee, Diana Brinton Lee, Henry

L'EXPOSITION INTERNATIONAL DU SURRÉALISME

L'Exposition Internationale du Surréalisme s'est tenue à Londres aux New Burlington Galleries du 11 Juin au 4 Juillet 1936.

Elle comprenait environ 390 tableaux, sculptures, objets, collages et dessins. Sur 68 exposants, 23 étaient anglais. 14 nations étaient représentées.

Le comité organisateur était composé, pour l'Angleterre, de Hugh Sykes Davies, David Gascoyne, Humphrey Jennings, Rupert Lee, Diana Brinton Lee, Henry Moore, Paul Nash, Roland Penrose, Herbert Read, assistés par

1

(see pages 44–5). He and Toyen became close to Breton and other Parisian Surrealists and participated in many of the international Surrealist exhibitions of the 1930s and 1940s.

Haunting, beautiful and thought-provoking, Toyen's *Deserted Den* (1937; page 47) could stand for her personal rejection of gender stereotypes. Symbolically abandoning the 'corset' and the constraints of her gender, Marie Čermínová changed her name to rid it of gender specificity (in Czech, the ending of names indicates gender). Čermínová became 'Toyen', an ungendered pseudonym, adapted from the French word *'citoyen'* (citizen). Now she could be known as an artist – and not a 'female artist'. Toyen was also interested in Freud's ideas: absent figures, ghostly apparitions, crumbling walls, animals and erotic imagery are typical of her dreamlike, often nightmarish, paintings and illustrations of the 1930s.

The exhibition 'Kubisme-Surrealisme' in Copenhagen, organized by Dane Bjerke-Petersen with the help of Freddie, Erik Olson of the Swedish Halmstad Group, Max Ernst and Breton, also took place in 1935. Freddie wrote that 'Surrealism means revolution within art, within everything . . . Our foundations are the universally human, the subconscious, instincts, dreams. There, all human beings are alike.' The same year, Breton went to Santa Cruz in Tenerife (the Canary Islands) for the 'Universal Surrealism Exhibition'. While there, he declared Tenerife a Surrealist island.

Some two thousand people attended the opening of the London 'International Surrealist Exhibition' in 1936

Special international bulletins were published to record the Surrealist exhibitions of 1935 and 1936 held in Prague (in Czech and French, no. 1, April 1935), Santa Cruz in Tenerife (in Spanish and French, no. 2, October 1935), Brussels (in French, no. 3, August 1936) and London (in English and French, no. 4, September 1936). The most important of these exhibitions was the London 'International Surrealist Exhibition' in 1936. The exhibition featured sixty-eight exhibitors representing fourteen nationalities. It was enthusiastically received, if not fully understood, by the public – some two thousand people attended the opening by Breton and around a thousand people attended each day during its run (11 June–4 July 1936).

The English artist and patron Roland Penrose organized the English contribution to the 'International Surrealist Exhibition'.

Penrose first joined the Surrealists in Paris in 1928, before returning to London and becoming a driving force in establishing British Surrealism.

The Belgian Surrealist Mesens also came to London to help organize the exhibition and then stayed on and with Penrose helped to nurture and promote Surrealism in Britain. Penrose bought the London Gallery in 1938 and with Mesens as its director, it quickly became the headquarters for Surrealism in England until the war forced its closure in 1940. Other prominent British Surrealists included Henry Moore, Edward Burra, Desmond Morris, Eileen Agar, Conroy Maddox and Paul Nash.

-

The exhibition 'Fantastic Art, Dada, Surrealism' included 700 objects by 157 artists, dating from 1450 to 1936

-

At the end of 1936 the landmark exhibition 'Fantastic Art, Dada, Surrealism' was held at the Museum of Modern Art in New York. The huge survey was organized by museum director Alfred H. Barr and was accompanied by an extensive catalogue. The exhibition included 700 objects by 157 artists, dating from 1450 to 1936. In it, Barr navigated a route from the 'fantastic art' of the fifteenth and sixteenth centuries (with work by Giuseppe Arcimboldo and Hieronymus Bosch; see pages 24–5) via William Blake (see page 53) in the late eighteenth and early nineteenth centuries to Lewis Carroll, Odilon Redon and Henri Rousseau in the nineteenth century, through to twentieth-century pioneers Chagall, de Chirico and Duchamp, and on to an extensive selection of Dada and Surrealist artists from around the world.

American Joseph Cornell was one of the contemporary artists included and he made his first shadow-box construction especially for the exhibition (page 52). Using the Surrealist practice of unexpected juxtaposition lends his boxes an archaeological and theatrical feel as they usually contain fragments of unrelated found objects, often once precious, lovingly arranged into miniature scenes in glass-fronted boxes. Cornell described this initial box as 'a real "first-born" of the type of case that was to become my accepted milieu'. One of the press releases for the exhibition highlighted the:

drawings and paintings of marvellous and fantastic machines devised by artists during the past 300 years . . . drawings and

Roland Penrose
Le Grand Jour, 1938
Oil on canvas, 76.2 x
101 cm (30 x 39⅞ in.)
Tate, St Ives

Penrose wrote that *Le Grand Jour* is 'a collage painting although nothing but paint has been applied to the canvas. The images are unrelated to each other but by coming together like images in dreams they produce new associations which can be interpreted in whatever way the spectator may feel inclined.' This painting was exhibited in 'Exposition internationale du surréalisme' at the Galerie Robert in Amsterdam in 1938 and in Penrose's first solo exhibition at the Mayor Gallery in London in 1939.

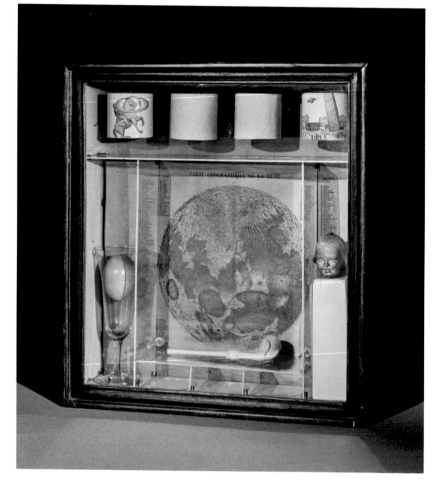

Joseph Cornell
Untitled (Soap Bubble Set), 1936
Mixed media
39.4 x 36.1 x 13.8 cm
(15⅝ x 14¼ x 5½ in.)
Wadsworth Atheneum
Museum, Hartford

This soap bubble set box was Cornell's first imaginary themed construction. In it a clay pipe, used to blow bubbles, is placed so that it looks as if it has just blown a huge bubble, which has become the moon.

paintings of fantastic machines by Picabia, Klee and Man Ray carry the imagination into present-day Surrealism and its most popular expression in the drawings of Rube Goldberg and in the animated fantasies of the world's best-loved Surrealist, Mickey Mouse . . . If Mickey Mouse in his peregrinations does not cavort 'in the omnipotence of the dream' and 'in the absence of all control exercised by the reason,' [referring to Breton's first *Manifesto of Surrealism*] then no one does or can.

Rube Goldberg was an extremely popular American cartoonist, whose trademark 'invention' cartoons caricatured modern machinery and the United States as the land of inventors and crazy gadgets. American animator Walt Disney, Mickey Mouse's creator, was represented in the exhibition by his fantastic machine, the 'wolf pacifier' (from the animated cartoon *Three Little Wolves*, 1936). The exhibition also included samples of commercial and journalistic

William Blake
'With dreams upon my bed, Thou scarest me and affrightest me with visions', 1825
Engraving, 21.27 x 16.83 cm (8⅜ x 6¾ in.)
Minneapolis Institute of Art, Minneapolis

Blake was an English poet, painter, printmaker and mystic whose visionary imagination attracted the Surrealists. This is one of his engravings for *The Book of Job*, published in 1825. It was one of a number of works by Blake included in the 'Fantastic Art, Dada, Surrealism' exhibition at the Museum of Modern Art in New York in 1936.

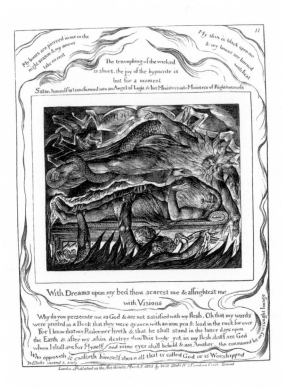

works that were Surrealist in nature, demonstrating just how pervasive and far-reaching the movement's influence already was by 1936.

The internationalization of the movement continued in 1937 with the tour of the 'Exhibition of Surrealist Works from Overseas' in Japan. Organized by Shuzo Takiguchi and Tiroux Yamanaka in collaboration with Paul Éluard, Georges Hugnet and Roland Penrose, it travelled to Tokyo, Osaka, Kyoto and Nagoya. This seminal exhibition was hugely influential on the development of the art of, for example, Kansuke Yamamoto, who was a poet and a leading Surrealist photographer in Japan.

Kansuke Yamamoto
Title unknown, late 1930s
Gelatin silver print,
19.2 x 28.6 cm
(7⅝ x 11⅜ in.)
Taka Ishii Gallery, Tokyo

True to Yamamoto's signature style, this picture fuses Surrealist techniques (such as collage, close-ups and photomontage) and unusual juxtapositions with Japanese motifs.

The smell of roasting coffee and the sound of hysterical laughter also bombarded the viewer in the dusty, dimly lit warehouse-like room

The culmination of Surrealism before the war was the 'Exposition internationale du surréalisme' held at the Galerie Beaux-Arts in Paris in 1938. In this exhibition Surrealism became a multisensory, multidisciplinary, all-encompassing, immersive experience. Visitors

were greeted in the courtyard by Dalí's *Rainy Taxi* (1938; below), an old taxi covered with vines, occupied by two mannequins – a chauffeur wearing a shark's head and goggles, and a female passenger covered with live snails, both drenched by water dripping from the taxi's roof. Then the visitor walked along a Surrealist street lined with sixteen mannequins 'dressed' by various artists leading to the main hall. There they entered a grotto-like environment with Duchamp's coal-sack ceiling, an installation of 1,200 coal sacks suspended from the ceiling over a stove lit with a single bulb.

There was a double bed in each corner of the room, a pond, a floor covered with leaves and moss, and paintings on revolving doors. The smell of roasting coffee and the sound of hysterical laughter also bombarded the viewer in the dusty, dimly lit warehouse-like room. The laughter came from Oscar Domínguez's *Jamais* (*Never*; 1937), a gramophone with mannequin legs coming out of it so that it looked like a woman was being devoured head first.

Visitors were supplied with flashlights in case they wanted to see something better in this dreamlike Surrealist environment. The *Dictionnaire abrégé du surréalisme*, edited by Breton and Éluard with a cover by Yves Tanguy, was published to accompany the exhibition, a departure from the standard catalogue. The dictionary

Salvador Dalí
Rainy Taxi, 1938
Photographed at the
'Exposition internationale
du surréalisme', Galerie
Beaux-Arts, Paris

**Dalí created another
temporary version of
Rainy Taxi for his Dream
of Venus Pavilion for the
New York World's Fair in
1939 (see page 121) and
a permanent one for his
Dalí Theatre-Museum
in Figueres, Spain
(1974–85).**

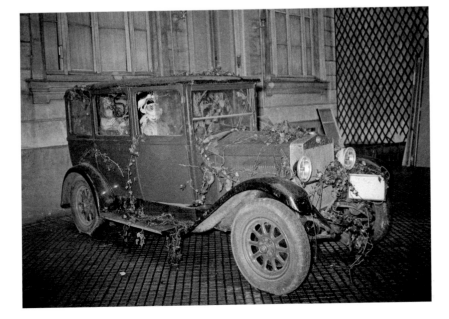

Dorothea Tanning
Birthday, 1942
Oil on canvas,
102.2 x 64.8 cm
(40¼ x 25⅝ in.)
Philadelphia Museum of
Art, Philadelphia

Tanning described how
her painting evolved:
'At first there was only
that one picture, a self-
portrait. It was a modest
canvas by present-day
standards. But it filled
my New York studio, the
apartment's back room,
as if it had always been
there. For one thing, it
was the room; I had
been struck, one day,
by a fascinating array
of doors – hall, kitchen,
bathroom, studio –
crowded together,
soliciting my attention
with their antic planes,
light, shadows, imminent
openings and shuttings.
From there it was an
easy leap to a dream of
countless doors.'

format itself allowed for the unexpected juxtapositions and encounters so central to Surrealism. While the Surrealists found the exhibition amusing, others found the brooding atmosphere disturbing. Writing about it later, Breton commented: 'We did not deliberately create that atmosphere: it merely conveyed the acute sense of foreboding with which we anticipated the coming decade.'

WARTIME SURREALISM

The outbreak of war in Europe sent many Surrealists into exile. During the mid- to late 1930s, many important European avant-garde artists sought refuge in the United States, mainly in New York. Breton, Matta, Ernst, Chagall, Dalí and Tanguy were among those Surrealists who spent the war years in the USA. New York was a haven for artistic refugees, in terms of safety and in having a growing arts scene made up of those who had recently been made aware of their work and importance in the Museum of Modern Art exhibition. Americans Cornell, Kay Sage, Peter Blume, Enrico Donati, Federico Castellón, Frederick Kiesler, Dorothea Tanning and Arshile Gorky are known for their work in the orbit of Surrealism.

Tanning is one of those who discovered Surrealism in New York in 1936 at the 'Fantastic Art, Dada, Surrealism' exhibition at the Museum of Modern Art. Seduced by the work, she was thrilled to meet some of the Surrealists-in-exile in New York in the 1940s. She is known for her precise figurative dreamlike scenes, such as *Birthday* (1942; opposite), which brought her to the attention of the art world.

Max Ernst named the painting when he visited Tanning's studio while scouting for the 'Exhibition by 31 Women', which was held at Peggy Guggenheim's Art of This Century Gallery in New York in 1943. It featured works by a number of Surrealists, including Tanning, Leonora Carrington, Leonor Fini, Valentine Hugo, Meret Oppenheim, Kay Sage and Jacqueline Lamba Breton. Oppenheim showed her infamous *Object* (page 35) and Tanning *Birthday*.

Mexico was another attractive spot for European exiles. In 1938 Breton spent four months in Mexico on a lecture tour. While there he met his idol, exiled Russian Marxist Leon Trotsky, and Mexican artists and intellectuals, including Frida Kahlo and Diego Rivera. On his return to France, he shared his enthusiasm for the country in the Surrealist publication *Minotaure*, in a special section entitled 'Souvenir du Mexique' illustrated with photographs by Manuel Álvarez Bravo. Spanish Remedios Varo, Austrian Wolfgang Paalen, French Alice Rahon, Peruvian César Moro and British Leonora

Carrington and Edward James are among those who made their homes there. In 1940 Paalen and Moro organized the 'Exposición internacional del surrealismo' in Mexico City, which included first and second generation international Surrealists and Mexican artists whose work shared similar sensibilities, such as Kahlo, Rivera, Álvarez Bravo and painter Guillermo Meza. Expats Carrington and Varo became close friends and collaborators while in Mexico, exploring their shared interests in fairytales, alchemy and magic.

-

The Art and Liberty Group tackled issues such as police brutality and prostitution with their Surrealist imagery

-

Elsewhere, new groups of Surrealists continued to form. The Art and Liberty Group was founded in March 1939 in Cairo, Egypt. Poet George Henein and painters Ramses Younane, brothers Anwar and Fouad Kamel and Kamel El-Telmissay were inspired by Breton's Paris group. The group stressed the importance of individuality and the freedom of the imagination and tackled issues such as police brutality and prostitution with their Surrealist imagery. Younane was one of the central figures of the Art and Liberty collective, which had close ties to its European counterparts. He was among those included in Breton's 1947 'Exposition internationale du surréalisme' in Paris and Prague (page 60).

In 1940 the Romanian Surrealist group was formed in Bucharest by poets Gherasim Luca, Gellu Naum and Virgil Teodorescu and visual artists Paul Păun and Dolfi Trost. Păun was also a poet, physician and surgeon. His Surrealist drawings of the period are typically in black ink and/or pencil and combine abstraction and figuration, using automatic techniques and hatching (page 61). The five members of the Bucharest group of Surrealists studied and discussed all aspects of Surrealism clandestinely during the war. Once the war ended they announced themselves on the international scene with a flurry of activity – manifestos, exhibitions and publications. They joined ranks with Breton and his Surrealists in Paris in 1947.

In the early 1940s the group Les Automatistes was formed in Montreal, Canada. Its members, including Paul-Émile Borduas, Fernand Leduc and Jean-Paul Riopelle, were inspired by Surrealist automatism and committed to abstraction. Borduas's reading about the French Surrealists in the early 1940s was a turning point for him, leading to his first experiments in abstraction, inspired by automatic writing (page 62).

Remedios Varo
Titeres vegetales (Vegetal Puppets), 1938
Oil and paraffin on plywood, 88 x 79 cm (34¾ x 31⅛ in.)
Museo de Arte Moderno (INBA), Mexico City

The Spanish artist Varo moved to Paris in 1937 and became involved with the Parisian Surrealists, exhibiting with them and learning a variety of experimental techniques. In this early work, Varo dripped wax on to the surface of the canvas and added a head that resembles the artist to the twisted, fibrous shapes. The lone figure and the vegetation have become one in this beautiful, eerie work.

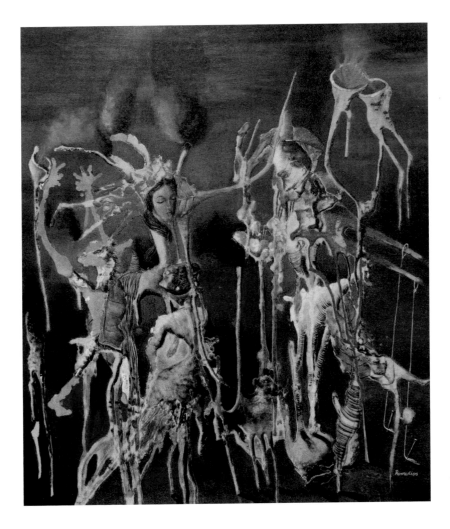

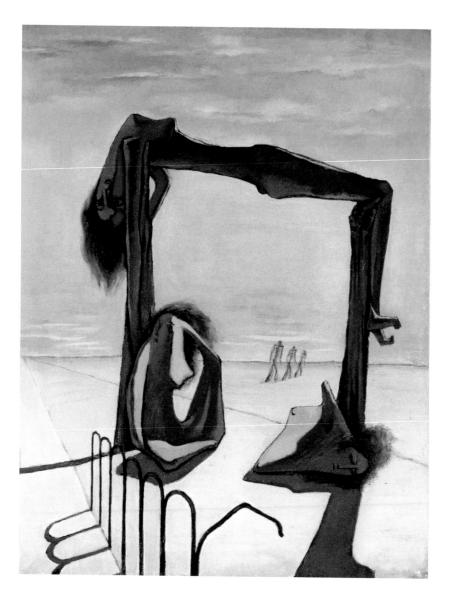

Ramses Younane
Untitled, 1939
Oil on canvas, 46.5 ×
35.5 cm (18⅜ × 14 in.)
H. E. Sh. Hassan M. A. Al
Thani collection, Doha

Younane's harrowing
images of the female
body were used to portray
society's injustices and
to agitate against the
exploitation of women.

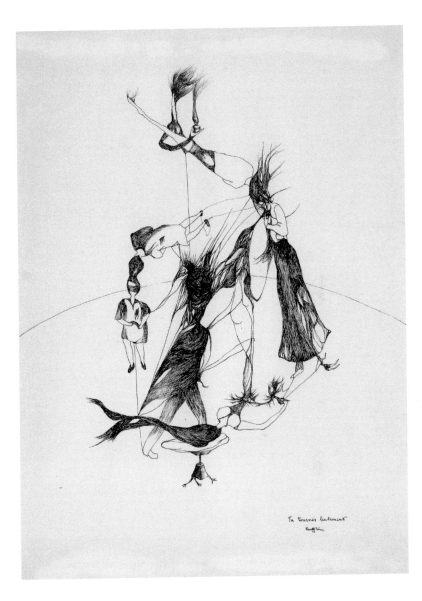

Paul Păun
Tu tournes lentement
(*You Turn Slowly*), 1943
China ink on paper,
27 cm x 36 cm
(10¾ x 14¼ in.)
Private collection

This delicate, dreamy
drawing was probably
included in Păun's debut
solo exhibition of his
Surrealist figurative ink
drawings in Bucharest
in 1945.

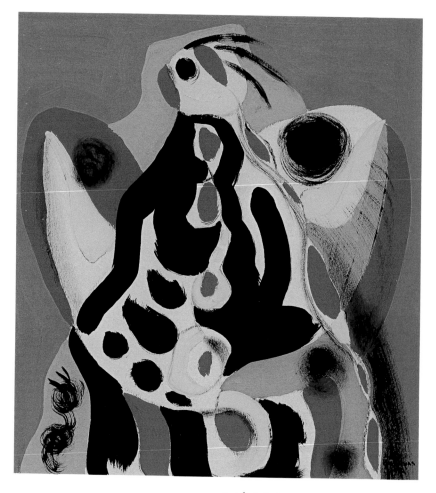

Paul-Émile Borduas
Sans titre (Un oiseau)
(Untitled [A Bird]), 1942
Gouache, charcoal
underdrawing, 27.2 x
25.2 cm (10¾ x 10 in.)
The Montreal Museum
of Fine Arts, Montreal

In 1942 Borduas
exhibited forty-five
automatic paintings in
gouache, which caught
the attention of a
group of young artists,
soon to be dubbed 'Les
Automatistes'.

SURREALIST PERIODICALS

Another powerful tool for spreading the Surrealist vision was the use of magazines. Some of the most important early publications were *La Révolution surréaliste* (Paris, 1924–9), *Variétés* (Brussels, 1928–30), *Documents* (Paris, 1929–30), *Le Surréalisme au service de la révolution* (Paris, 1930–33) and *Minotaure* (Paris, 1933–9). *Minotaure* was a lavish journal published by Albert Skira. Breton was one of its editors and in the thirteen issues that appeared, the artwork of Arp, Bellmer, Brauner, Dalí, Delvaux, Duchamp, Ernst, Giacometti, Magritte, Matta and others was showcased. Its high-quality photography and rich colour illustrations brought Surrealist imagery to a mainstream audience. The cover for *Minotaure*, no. 6, in 1935, was testimony to Man Ray and Duchamp's enduring friendship. The two artists had met in New York in 1915, became

Marcel Duchamp
Cover for *Minotaure*,
no. 6, Winter 1935,
Paris, with a collage of
Duchamp's *Rotorelief
No. 1 – Corolles – Modèle
Déposé* (*Corallas –
Registered Model*; 1935)
– and two views of Man
Ray's *Elevage de Poussière*
(*Dust Breeding*; 1920)

**Duchamp's *Rotoreliefs*
of 1935 are a set of
decorated cardboard
disks that when played
on a turntable create
undulating three-
dimensional illusions that
are both hypnotic and
suggestive, capturing the
disorienting and erotic
elements of Surrealism.**

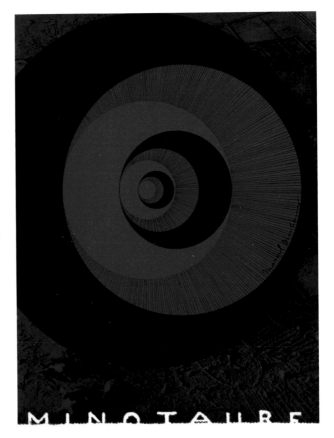

lifelong friends and often collaborated on projects. For *Elevage de Poussière*, Man Ray left the shutter on his camera open for an hour to record the dust accumulating on Duchamp's artwork *The Large Glass* (also known as *The Bride Stripped Bare by Her Bachelors, Even*, 1915–23), capturing the wonder, or the marvellous, in the everyday.

During the war three new Surrealist publications were started up in the Americas: *View: The Modern Magazine* (New York, 1940–47), *VVV* (New York, 1942–4) and *DYN* (Mexico City, 1942–4). Thirty-two issues of *View* magazine, edited by Charles Henri Ford, were published between 1940 and 1947. Duchamp was on the advisory board and the journal covered Surrealist activities, which helped spread information about the movement throughout the United States.

Wifredo Lam
Cover of *View: The Modern Magazine*, series V, no. 2, May 1945, New York

The Cuban artist Wilfredo Lam studied art in Cuba and Spain before spending time in Paris and becoming a protégé of Picasso. Lam joined the Surrealists in 1940, having been introduced to Breton by Picasso. This cover for *View* is in Lam's distinctive simplified style with hybrid figures that could be male or female, human, plant or animal.

KEY LOCATIONS

Paris, France
Brussels, Belgium
Prague, Czechoslovakia
Copenhagen, Denmark
Malmö, Sweden
London, England
Birmingham, England
Bucharest, Romania
Cairo, Egypt
Tokyo, Japan
Montreal, Canada
New York, NY, USA
Mexico City, Mexico
Budapest, Hungary
Barcelona, Spain
Halmstad, Sweden

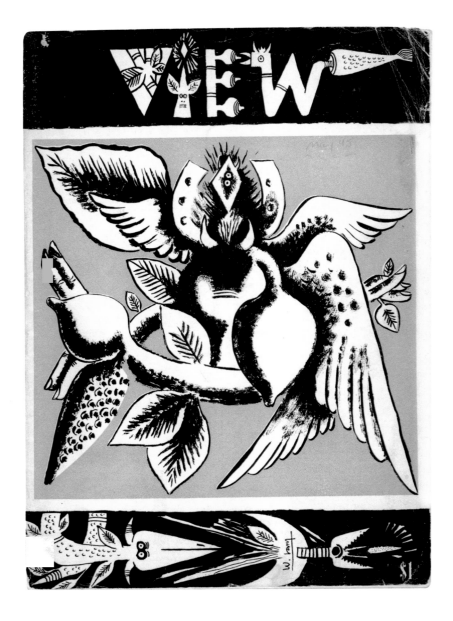

KEY INTERNATIONAL EXHIBITIONS OF SURREALISM

1925
'Exposition, la peinture surréaliste', Galerie Pierre, Paris, France

1931
'Newer Super-Realism', Wadsworth Atheneum, Hartford, CT, USA – first Surrealist exhibition in America, travelled to New York as 'Surrealism, Paintings, Drawings and Photographs', Julien Levy Gallery, New York, NY, USA (1932)

1934
'Exposition Minotaure', Palais des Beaux-Arts, Brussels, Belgium

1935
'Kubisme-Surrealisme', Den Frie Centre of Contemporary Art, Copenhagen, Denmark
'Exposition internationale du surréalisme', Mánes Gallery, Prague, Czechoslovakia
'Universal Surrealism Exhibition', Santa Cruz Athenaeum, Santa Cruz, Tenerife, Canary Islands

1936
'International Surrealist Exhibition', New Burlington Galleries, London, England
'Fantastic Art, Dada, Surrealism', Museum of Modern Art (MoMA), New York, NY, USA
'Exposition surréaliste d'objets', Galerie Charles Ratton, Paris, France

1937
'Exhibition of Overseas Surrealist Works', Nippon Salon, Tokyo, Japan, travelled to Osaka, Kyoto and Nagoya
'Surrealist Objects & Poems', London Gallery, London, England

1938
'Exposition internationale du surréalisme', Galerie Beaux-Arts, Paris, France
'Exposition internationale du surréalisme', Galerie Robert, Amsterdam, Netherlands

1940
'Exposición internacional del surrealismo', Galeria de Arte Mexicano, Mexico City, Mexico

1942
'First Papers of Surrealism', Whitelaw Reid Mansion, New York, NY, USA

1945–6
'Surréalisme', Galerie des Éditions la Boétie, Brussels, Belgium

1947
'Exposition internationale du surréalisme', Galerie Maeght, Paris, France, travelled to Prague, Czechoslovakia and Chile (1948)

1959–60
'Exposition inteRnatiOnale du Surréalisme' (EROS), Galerie Daniel Cordier, Paris, France

1960
'Surrealist Intrusion in the Enchanter's Domain', D'Arcy Galleries, New York, NY, USA

1961
'Mostra internazionale del surrealismo', Galleria Schwarz, Milan, Italy

1965
'Exposition internationale du surréalisme', Galerie de l'Œil, Paris, France

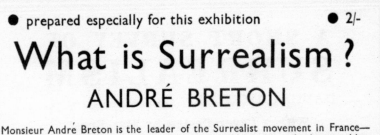

● prepared especially for this exhibition ● 2/-

What is Surrealism?
ANDRÉ BRETON

Monsieur André Breton is the leader of the Surrealist movement in France—
the most vital movement in contemporary art and literature. In this pamphlet,
specially written for the occasion of the first International Surrealist Exhibition
to be held in London, Monsieur Breton explains exactly what surrealism stands
for in painting, sculpture and politics. It is revealed, not as one more little
sectarian affair destined to flutter the cafes of London and Paris, but as
a deliberate and even a desperate attempt to transform the world. Surrealism
may amuse you, it may shock you, it may scandalize you, but one thing is
certain : you will not be able to ignore it.

Illustrated, 2/-
24 Russell Square FABER & FABER London, W.C. I

André Breton
Advertisement for 'What
is Surrealism?', 1936
Exhibition catalogue
for the 'International
Surrealist Exhibition',
London, page 9

This advertisement was
for André Breton's 'What
is Surrealism?' (1936),
a pamphlet written on
the occasion of the first
'International Surrealist
Exhibition' in London.

MAKING SURREALIST ART

-

**I try to create fantastic things,
magical things, dreamlike things.
The world needs more fantasy**

-

Salvador Dalí

1940

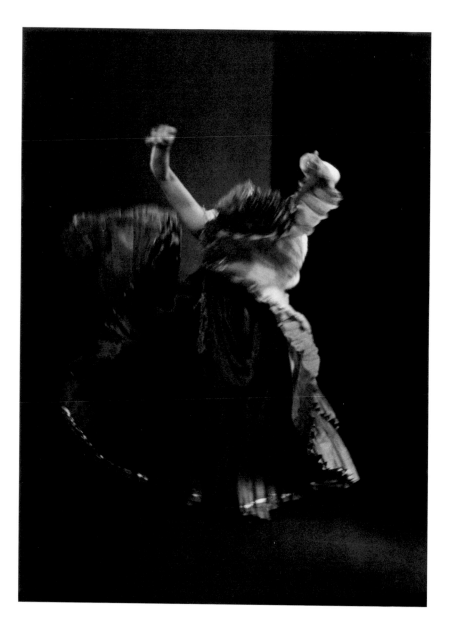

For the Surrealists and André Breton, Surrealism was as much an attitude, an outlook on life, as it was an approach to making art. They sought to collapse the divide between imagination and reality. The new state of being would be reached via 'objective chance', by experiencing the sensation caused when ordinary but unrelated objects were brought together in unexpected encounters, such as that described by Lautréamont (see page 11). This would challenge preconceived notions of reality, lead to an opening between worlds and produce an otherworldly heightening of the senses that would reveal the inherent poetry and strangeness of reality.

Man Ray
Explosante-fixe –
Prou del Pilar, 1934
Gelatin silver print, 12.1 x
9.2 cm (4⅞ x 3⅝ in.)
Centre Pompidou, Paris

In this photograph Man Ray caught – or fixed – a dancer in full force who has just dramatically stopped but her skirts are still billowing around her.

Beauty is a disordering of the senses, a disruption experienced as a shock that is both exciting and disorientating

This new reality was 'the marvellous' and 'only the marvellous is beautiful', as Breton declared in the first *Manifesto of Surrealism* (1924). In the final sentence of his novel *Nadja* (1928), Breton wrote: 'Beauty will be CONVULSIVE or it will not be.' He elaborated further in his book *L'Amour fou* (*Mad Love*; 1937): 'Convulsive beauty will be veiled-erotic, fixed-explosive, magic-circumstantial or it will not be.' So, the marvellous is beautiful and beauty is convulsive. As such, beauty is a disordering of the senses, a disruption experienced as a shock that is both exciting and disorientating. The more profound the juxtapositions created, the more spontaneously they arise, the greater the impact or jolt will be. Images that could best capture or convey this unnerving, giddy experience were deemed to be Surrealist. Man Ray's *Explosante-fixe – Prou del Pilar* (opposite) was originally published in *Minotaure*, no. 5, 1934, and then in 1937 in Breton's *Mad Love* as an example of 'fixed-explosive' convulsive beauty. It captures the crazy, euphoric, out-of-control feeling of 'mad love' and desire.

Freudian theories were fashionable in Paris in the 1920s and 1930s as his work was translated into French. Artists were fascinated by the powerful, provocative imagery that his ideas suggested. Hungarian artist Lajos Vajda, for example, became acquainted with Surrealism when he lived in Paris between 1930 and 1934. When he returned to Hungary, he fused Surrealist ideas and motifs with his interest in folk art and religious iconography into a distinctive style that he called 'constructive surrealist patterning'. His paintings from the late 1930s, such as *Monster in Blue Space* (1939; overleaf), feature fearsome masks and monsters floating in

Overleaf: Lajos Vajda
Monster in Blue Space,
1939
Pastel, chalk, charcoal,
pencil and India ink on
paper, 63 x 94.5 cm
(24⅞ x 37¼ in.)
Janus Pannonius
Museum, Pécs

This is typical of Vadja's work of the late 1930s with its sense of foreboding.

richly coloured barren landscapes, conveying primordial fears and his own nightmares, as war loomed and his health deteriorated.

Artists experimented with different strategies to get to the 'uncanny': mimicry, doubling, rotation, coincidence, repetition and close-ups were all mined for their potential to render the familiar strange. Doubling, for instance, be it through double exposures, collage or the use of mirrors, could produce spooky effects and ghostly associations.

Eyes, insects, fragmented bodies and disembodied heads are important motifs in Surrealist iconography. The praying mantis particularly appealed to the Surrealists for its humanoid form and mating rituals, which encapsulated the Freudian instinctual drives of love and death. The image of the female praying mantis represented the archetypal 'killer female' as she decapitates and eats the male while copulating (below). Surrealists were also fascinated by masks – African masks, industrial masks, gas masks, carnival masks – for their dehumanizing qualities (page 76–7). In Surrealist work, the Dada love of machines turns into a fear of the automaton, a horror of the dead coming to life, and masks, dolls and mannequins

Oscar Domínguez
La mante religieuse
(*Praying Mantis*), 1938
Oil on canvas, 38.3 x
46 cm (15⅛ x 18⅛ in.)
Private collection

Here Domínguez portrays a vicious-looking female praying mantis devouring her partner in a surreal landscape.

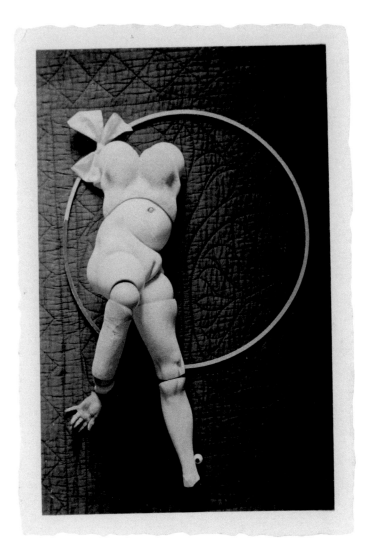

Hans Bellmer
La Poupée (*The Doll*),
1935
Gelatin silver print, 8.9 x
6.3 cm (3⅜ x 2½ in.)
Ubu Gallery, New York

Bellmer's nightmarish
doll images look like
police crime-scene
photos of unspeakable
horrors and are some
of the most disturbing
Surrealist images created.

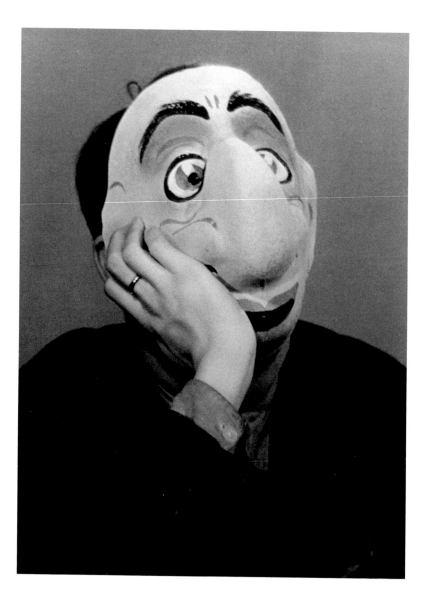

Jacques-André Boiffard
Sous le masque (*Behind the Mask*), 1930
Gelatin silver print,
22.4 x 16.8 cm
(8⅞ x 6⅝ in.)
Centre Pompidou, Paris

Boiffard's photographs of men wearing masks accompanied an essay by Georges Limbour, 'Eschyle, le carnaval et les civilisés' (Eschylus, Carnival and Civilized Peoples) in the Surrealist review *Documents* (no. 2, February 1930).

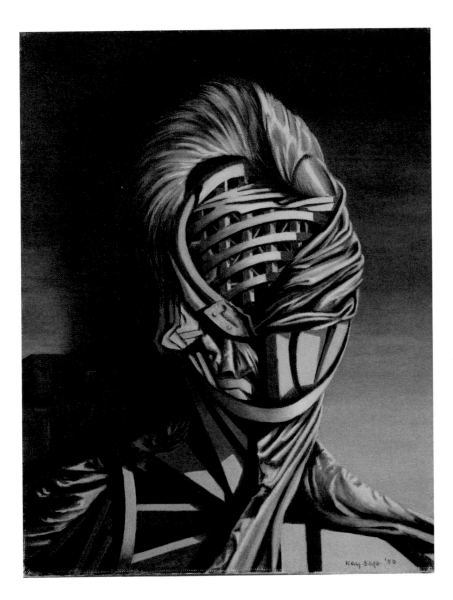

Kay Sage
Small Portrait, 1950
Oil on canvas, 36.8 x
28.9 cm (14½ x 11½ in.)
Frances Lehman Loeb Art
Center, Poughkeepsie,
New York

Here a strange steel
latticework has become
the scaffolding of
a human (?) head,
meticulously painted by
American artist Kay Sage
in her trademark palette
of muted greys, greens
and ochre.

are recurring images. Hans Bellmer's photographs of dismembered dolls, for example, disturb so profoundly because they seem to erase the line between the animate and inanimate (page 75). Most Surrealist work addresses such disquieting drives as fear, hidden desire and eroticism.

-

Art was not an end, but a means to something greater – the pursuit of the marvellous

-

There were no particular dictates about a Surrealist style, for art was not an end, but a means to something greater – the pursuit of the marvellous. The Surrealist atmosphere was liberating and fostered many experiments to reveal images that could create the frisson of the marvellous. In order to bypass the rational mind to get to the uncensored ideas and emotions in the unconscious imagination, many artists turned to automatism and dream imagery, resulting in two broad visual types of paintings: the so-called 'biomorphic' or 'organic' Surrealism of Spanish Joan Miró, French André Masson, Chilean Roberto Matta and German-French Jean (Hans) Arp; and the 'dream' Surrealism of Spanish Salvador Dalí, Belgian René Magritte and French Yves Tanguy and Pierre Roy.

Joan Miró
Le renversement
(*The Toppling/Somersault*),
1924
Oil, graphite, charcoal
and tempera on canvas
board, 92.4 x 72.8 cm
(36⅜ x 28¾ in.)
Yale University Art
Gallery, New Haven

Miró's bold, delicate paintings teeming with imaginary life were made using a mixture of chance and planning.

AUTOMATISM

Automatism was one of *the* Surrealist methods of creating. An artist draws or paints purposely without thinking, rather like doodling, so that the images come straight from his or her unconscious mind. Miró painted his bright biomorphic forms on fields of saturated colour instinctively, declaring: 'As I paint, the picture begins to assert itself under my brush.' He used automatic techniques both to create finished works and also at the level of the sketch – as a starting point that he would then consciously work up to a completed artwork. Describing the first stage of his work as 'free, unconscious', Miró added that 'the second stage is carefully calculated'. To make some of his paintings, Miró spread paint 'in a random manner' (pouring, flinging, spreading with a rag) over a canvas, which he had unevenly primed so that paint would not soak into it in the same degree all over. Then he would deliberately add shapes and lines that he had worked on in preparatory sketches.

Miró's friend Masson also embraced automatic techniques as a means to make his images. He began making automatic drawings

André Masson
Lancelot, 1927
Oil, glue-size, sand, paint
and ink on canvas, 46 x
21.5 cm (18⅛ x 8½ in.)
Centre Pompidou, Paris

**Breton bought a painting
from Masson's first solo
exhibition in Paris in
1924 and invited him
to join the Surrealists.
Masson began making
automatic drawings and
paintings to convey his
'feelings of heightened
urgency and conflicting
impulses'.**

with pen and India ink in 1924 in which images would begin to appear
in a web of rapidly drawn lines. Masson would then either leave the
drawings as they were, or develop them further. In 1927 he began
a series of sand paintings, in which he randomly spread glue on a
canvas, then poured on sand, tipping the canvas around so that the
sand would stick to the areas with glue. Then, as in his drawings,
he would add colour or line to bring out the images he saw there,
as in *Lancelot* (1927; opposite). He explained: 'I begin without an
image or plan in mind, but just draw or paint rapidly according to my
impulses. Gradually, in the marks I make, I see suggestions of figures
or objects. I encourage these to emerge . . .'

Contradictory images came with the persistence and speed of erotic dreams

For the German artist Max Ernst, using automatic methods
allowed him to take part as a 'spectator at the birth of his work'.
In 1925, while staying in a French seaside hotel, he took up
frottage (French: rubbing) as his automatic technique. He made
a series of rubbings of the wooden floorboards on pieces of paper
with black lead. In the markings he produced he was excited to
see 'contradictory images that came, one on the other, with the
persistence and speed of erotic dreams'. He also took rubbings of
other materials, such as leaves and sticks, as used in *The Wheel
of Light* (c.1925; page 82). For Ernst, *frottage* was 'the real
equivalent of that which is already known by the term automatic
writing'. He adapted the technique to painting in 1927, calling it
grattage (French: scraping). Here he would place a canvas spread
with pigment on a textured surface and scrape the paint away to
reveal an imprint of the surface or shape of an object below (page
83). Miró and others also used *grattage*. These techniques allowed
Surrealists to incorporate chance patterns and shapes from the
physical world into their drawings and paintings.

Later, around 1929, Ernst began a series of collage-novels,
of which the most famous is *Une Semaine de bonté* (*A Week of
Kindness*, 1934; see page 85). Cutting up and rearranging Victorian
steel engravings, literally dissecting the past, he produced bizarre
fantasies out of the safe bourgeois world in which he had grown up.
The collages were constructed so precisely that when they were
printed photomechanically, the joins were invisible, making the
surreal compositions look as if they naturally appeared this way.

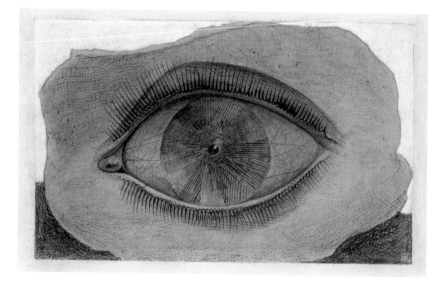

Max Ernst
La roue de la lumière
(The Wheel of Light),
from *Histoire naturelle*
(Natural History), c.1925,
published 1926
Frottage, pencil on paper,
25 × 42 cm (9⅞ × 16⅝ in.)
Private collection,
Switzerland

Ernst transformed the
rubbing of a leaf into the
white of the eye. Eyes
were very popular images
in Surrealism, as windows
to the soul and symbols
of inner vision, intellect
and spirit.

Max Ernst
Fleurs de neige
(*Snow Flowers*), 1929
Oil on canvas, 130 ×
130 cm (51¼ × 51¼ in.)
Fondation Beyeler,
Riehen/Basel

**Ernst created this
painting using both
frottage and *grattage*.**

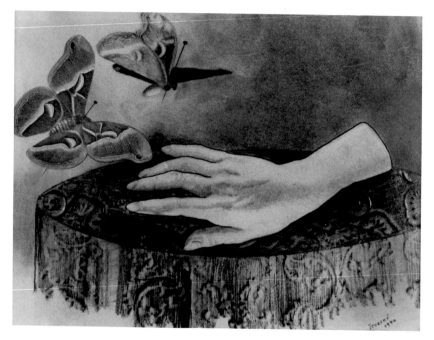

Jindřich Štyrský
Little Alabaster Hand, 1940
Pencil, *frottage* and collage
on paper, 21.9 x 29.8 cm
(8⅝ x 11¾ in.)
Private collection, courtesy
Ubu Gallery, New York

Here Štyrský combines
frottage, collage and
drawing to create an
image of a disembodied
hand with two butterflies
hovering above. Hands and
insects often feature in
Surrealist work.

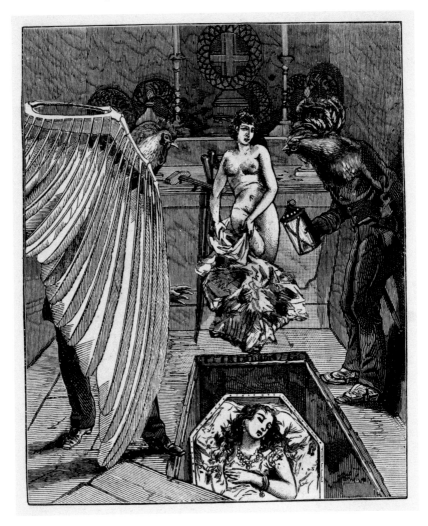

Max Ernst
Le rire du coq 3 (*The Cockerel's Laughter*), 1934
From the collage-novel *Une Semaine de bonté*
Engraving, 18.1 x 15.2 cm (7¼ x 6 in.)
Ubu Gallery, New York

This nightmarish image is from Ernst's most elaborate collage-novel of 182 images. This is the third plate for *Thursday*, whose symbolic element was '*Le noir*' (Darkness).

Ernst, echoing Lautréamont, described these Surrealist compositions as a 'linking of two realities that by all appearances have nothing to link them, in a setting that by all appearances does not fit them'.

The top paper was lifted off just before the paint dried to reveal surreal landscape-like transfer images

In 1936 Spanish artist Oscar Domínguez pioneered 'decalcomania' (from the French *décalquer*, meaning 'to transfer') for Surrealism. Black paint was spread on a piece of paper and another sheet was pressed on top of it while the paint was still wet, as in the picture opposite. The top paper was lifted off just before the paint dried to reveal surreal landscape-like transfer images. Breton and others were captivated by Domínguez's 'decalcomanias', seeing them as another automatic technique. Ernst, Breton and French Georges Hugnet are others who used the technique. A selection of 'decalcomanias' were reproduced in the June 1936 issue of *Minotaure*.

A candle is quickly grazed over a sheet of paper or prepared canvas leaving sooty marks

About the same time, Austrian Wolfgang Paalen invented *fumage* (French: smoking), using smoke from a candle to 'draw' shapes. A candle is quickly grazed over a sheet of paper or prepared canvas leaving sooty marks. The strange, dreamlike formations are then worked over by the artist, as in *Pays Interdit* (*Forbidden Land*, 1936–7; page 88) by Paalen. Dalí, Matta and Remedios Varo are others who used this method. Breton was captivated and wrote:

> Wolfgang Paalen is the one who has incarnated most vigorously this way of seeing – of seeing around oneself and within oneself . . . I believe that no more serious or more continuous effort has ever been made to apprehend the texture of the universe and make it perceptible to us.

Photographers also explored methods related to automatism and chance. American Man Ray's rayographs, for instance, are photographs that are made by placing an object directly on to photographic paper, which is then exposed to light (without using

Oscar Domínguez
Decalcomania, 1935
Decalcomania (gouache transfer) on paper, 35 x 24.5 cm (13⅞ x 9¾ in.)
Sammlung Scharf-Gerstenberg, Nationalgalerie (SMB), Berlin

Domínguez was from Tenerife, and Breton dubbed him 'the dragon tree of the Canaries'. By 1933 his paintings and objects had come to the attention of Breton and Éluard and he quickly became a central figure in Surrealist activities.

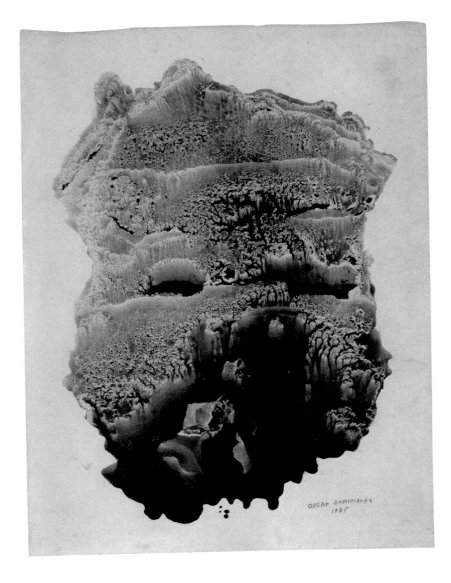

Wolfgang Paalen
Pays Interdit (Forbidden Land), 1936–7
Oil and candlesmoke
(*fumage*) on canvas
92.7 x 59.5 cm (36½
x 23½ in.)
Private collection, Berlin

Paalen joined the Parisian Surrealists in 1935. This is the first painting in which he integrated the evocative patterns created by the smoke and soot of a candle into an alien landscape.

a camera). He discovered the process accidentally in 1921, when he placed a piece of photographic paper that he had forgotten to expose into the developer (page 90). In his book *Self Portrait* (1963), Man Ray explained:

> As I waited in vain a couple of minutes for an image to appear, regretting the waste of paper, I mechanically placed a small glass funnel, the graduate and the thermometer in the tray on the wetted paper. I turned on the light; before my eyes an image began to form, not quite a simple silhouette of the objects as in a straight photograph, but distorted and refracted by the glass more or less in contact with the paper and standing out against a black background, the part directly exposed to the light.

Man Ray's rayographs were created in the darkroom as opposed to earlier photographs made without a camera (called photograms), which were usually created by placing objects on light-sensitive paper and leaving them outside. The rayographs were mysterious and very popular. New Zealand artist Len Lye was one of those interested in Man Ray's technique. Lye made a number of camera-less images in the 1930s and 1940s, which he called 'shadowgrams' or photograms. *Self Planting at Night* (1930; page 91) is one of his earliest, made while he was living in London. Along with two other works, it was exhibited in 1936 in the 'International Surrealist Exhibition' in London. For these original photograms, he used household objects and moulded plasticine. Between 1946 and 1947 Lye returned to the technique and made a series of striking portraits of artists whom he knew and admired, such as Joan Miró, and his family. To a silhouette of the person's head, he added further details that represented them via a second or third exposure.

Man Ray and Lee Miller discovered 'solarization' when Miller accidentally exposed a developing print to light, creating an eerie silvery aura

Another happy mistake occurred in 1929: Man Ray and American Lee Miller, Ray's model-assistant-apprentice, discovered 'solarization' when Miller accidentally exposed a developing print to light. Blacks and whites were partially reversed, creating an eerie silvery aura. Miller used this method for the portrait of a woman thought to be the artist Meret Oppenheim (1930; page 92).

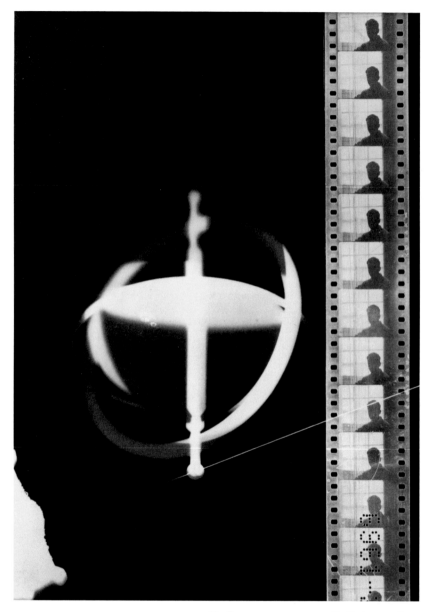

Man Ray
Untitled, c.1921
Rayograph, printed later
Gelatin silver print,
19.7 x 14.6 cm (7⅞ x 5¾ in.)
San Francisco Museum of
Modern Art (SFMoMA),
San Francisco

Man Ray's rayographs,
such as this early one
with a gyroscope and
a film strip, seem both
accidental and elegantly
composed.

Len Lye
Self Planting at Night,
1930
Photogram
Govett-Brewster Art
Gallery, New Plymouth

In 1947 Lye made a
photogram self-portrait,
in which this photogram was
superimposed on a silhouette
of his head – perhaps a
reference to how important
this image was to him.

The technique became popular with a number of Surrealists, including the Belgian artist Raoul Ubac.

When Ubac read the first *Manifesto of Surrealism* in 1929, he said it was 'a revelation and a calling'. Ubac also invented a photographic method called *brûlage* (French: burning, singeing). Calling it 'automatism of destruction', he would melt the emulsion on an exposed negative (by placing it over a pan of heated water) before printing it. Ubac commented on the results of this method: 'I treated a large number of my negatives in this manner – the result being for the most part disappointing, except in one case . . . a photo titled *La Nébuleuse*' (*The Nebula*, 1938; opposite).

Lee Miller
Solarized portrait of a woman (thought to be Meret Oppenheim), c.1932
Gelatin silver print, 24.1 x 19 cm (9½ x 7½ in.)
Lee Miller Archives, Chiddingly, East Sussex

This solarized portrait by American photographer Lee Miller shows how the brief overexposure creates a halo effect.

Raoul Ubac
La Nébuleuse, 1938
Brûlage, gelatin silver print,
40 x 28.3 cm (15¾ x 11¼ in.)
Centre Pompidou, Paris

Brûlage worked for Ubac
in this photograph; he
wrote that it transformed
'a woman in a bathing
suit into a thunderstruck
Goddess'.

93

André Breton, Valentine Hugo, Paul Éluard and Nusch Éluard
Exquisite Corpse, 1934
Crayon on paper, 31 x 24 cm (12¼ x 9½ in.)
Musee d'art et d'histoire, Saint-Denis

André Breton wrote in *The Exquisite Corpse, Its Exaltation* (1948): 'With the Exquisite Corpse we had at our disposal – at last – an infallible means of sending the mind's critical mechanism away on vacation and fully releasing its metaphorical potentialities.'

Overleaf: Salvador Dalí
The Persistence of Memory, 1931
Oil on canvas, 24.1 x 33 cm (9½ x 13 in.)
Museum of Modern Art (MoMA), New York

This painting has indeed persisted in popular memory, having been subjected to numerous versions, including ones by the creators of *Sesame Street*, *Dr Who* and *The Simpsons*.

EXQUISITE CORPSE

Another powerful way to inject one's Surrealism with automatism and chance was through collaboration and game playing. Around 1925 a group of Surrealist friends in Paris, including Breton, Tanguy, Marcel Duchamp and poet Jacques Prévert, invented a technique called 'cadavre exquis' (French: exquisite corpse). It was based on the old parlour game Consequences, in which players write something on a piece of paper, fold it so that it cannot be seen and pass it on to the next person, who then adds another fragment and passes it on. The group soon adapted it from a writing game into a collaborative way to draw – usually bodies.

The exquisite corpse will drink the new wine

What started as a game evolved into a useful technique to reach the collective unconscious and create really random juxtapositions. A phrase from their first game provided them with the name for the process and the resulting hybrid images: 'le cadavre – exquis – boira – le vin nouveau' (the exquisite corpse will drink the new wine).

Another important group project took place in 1940 when Breton and a group of his Surrealist friends (Wifredo Lam, Max Ernst, Jacqueline Lamba Breton, Oscar Domínguez, Victor Brauner, André Masson and Jacques Hérold) were in the port town of Marseille, France, trying to obtain exit visas for America to escape Nazi-occupied Europe. To pass the time, Breton proposed that they collectively design a set of playing cards that would reflect their heroes and beliefs.

Black Locks to represent knowledge, black Stars dreams, red Wheels revolution and blood and red Flames love

The court hierarchy of face cards was out, replaced by cards depicting Surrealist icons, such as Hélène Smith, the Comte de Lautréamont, Alice in Wonderland and Sigmund Freud, in the roles of Genius, Siren and Magus rather than King, Queen or Jack. The suits were also reimagined – with black Locks to represent knowledge, black Stars for dreams, red Wheels for revolution and blood and red Flames for love. The designs first appeared in *VVV* magazine, no. 2–3 (New York, March 1943) and were eventually

published as an actual deck of cards, 'Le Jeu de Marseille', by Grimaud in Paris in 1983 (see page 19).

Yves Tanguy
*Ni légendes ni figures
(Neither Legends nor
Figures)*, 1930
Oil on canvas, 81.6 x
65.1 cm (32⅛ x 25⅝ in.)
The Menil Collection,
Houston

**Tanguy's meticulously
painted dream-world
landscape, with its
flowing forms and
strange land features is
thought to be informed
by his memories of the
prehistoric megaliths
seen on childhood
vacations in Brittany, as
well as his impressions of
the African landscape on
a trip to Tunis in 1930.**

FANTASY AND DREAMS

In sharp contrast to the rather abstract forms of Surrealism derived from automatic techniques was the strand of figurative dream imagery. At the end of the 1920s there was a shift towards a more illusionistic Surrealism, as seen in the realistic-looking but irrational images of Salvador Dalí, René Magritte and Yves Tanguy, who were all influenced by the enigmatic Metaphysical art of Italian painter Giorgio de Chirico (see pages 16–17).

Dalí realistically rendered hallucinatory scenes full of unexpected juxtapositions

A genius of self-promotion, Dalí had a carefully turned up and waxed moustache that became a trademark of his appearance, and his art, behaviour and the way he looked became emblematic of Surrealism. Defining his method as 'paranoiac critical activity', he wanted to 'systematize confusion and thus help to discredit completely the world of reality'. Dalí's 'hand-painted dream photographs' are realistically rendered hallucinatory scenes full of unexpected juxtapositions, which explore his phobias and his desires.

The Persistence of Memory (1931; pages 96–7) is a small canvas with a big place in the career of Dalí and Surrealism in general. Uniting dream and reality and making the familiar unfamiliar, this painting introduced his iconic melting watches in a vast, barren landscape based on the cliffs near his home in Catalonia. The painting was exhibited in Paris and at the Wadsworth Atheneum, Hartford, Connecticut, in 1931, and then at the Julien Levy Gallery in New York in 1932 and 1933, before being purchased for the Museum of Modern Art in New York in 1934. The popularity of the painting helped make Dalí one of the most famous of the Surrealist artists.

While Dalí's works picture his own unconscious, Tanguy's hypnotic symbolic landscapes with geological formations envision the unconscious as if it were an actual place (opposite). His naturalistic-looking environments hover somewhere between reality and fantasy. Tanguy met Breton in 1925 and quickly became

a disciple. Breton called him 'my adorable friend . . . the painter of a terrible grace, in the air, below the ground and on the sea.'

René Magritte's work, meanwhile, asserts that the visible world is as valid a source of the marvellous as is the internal world of the unconscious. Magritte was interested in the relationship between objects, images and language. Layers of meaning and associations were made possible through the interface of the visual and the verbal, the conscious and the unconscious. His work focuses on the role of vision, the ways in which our intellect and emotions condition our perception of reality and, ultimately, question the reality we see.

Using a deadpan style reminiscent of the films of American Buster Keaton, Magritte's goal was to make 'everyday objects shriek aloud'. His work particularly appealed to the Surrealists, although he himself discouraged psychoanalytic readings: 'The true art of painting is to conceive and realize paintings capable of giving the spectator a pure visual perception of the external world.' The external world presented by Magritte is full of contradictions, dislocations, enigmas and strange juxtapositions.

The impact of Magritte's paintings comes from his use of a deliberately conventional painting style to portray his irrational images. In 1940 Magritte explained: 'I made paintings where the objects were presented with the appearance they have in reality, in a style sufficiently objective . . . I showed objects situated where we never find them.' While this is so for *Time Transfixed* (1938; opposite), which Magritte made for Surrealist patron Edward James's ballroom, the painting also calls to mind the unforgettable photographs of perhaps the most bizarre train derailment ever: the accident at Montparnasse Station in Paris of 1895, in which a train went through the station wall and crashed on to street level below.

The laboratory of Surrealism nurtured a wide range of styles and techniques, from the flamboyant provocations of Dalí to the quiet subversion of Magritte. Dalí and Magritte, in particular, were successful in their own lifetimes and their popularity has only continued to grow. Surrealist creativity reached all disciplines, to which we will turn in the next chapter.

René Magritte
Time Transfixed, 1938
Oil on canvas, 147 x
98.7 cm (57⅞ x 38⅞ in.)
The Art Institute of
Chicago, Chicago

Magritte stated:
'I decided to paint the image of a locomotive . . . In order for its mystery to be evoked, another immediately familiar image without mystery – the image of a dining room fireplace – was joined.' Here, a fireplace becomes a tunnel with a steam train rushing out of it, where the steam is the only aspect that lends a sense of motion – a great example of the 'fixed-explosive' of Breton's convulsive beauty.

KEY FEATURES

Strange juxtapositions, whimsy and dream imagery
Ambiguity, visual riddles
Play between title and image, love of visual and verbal puns
Themes of fear and desire
Experimental techniques

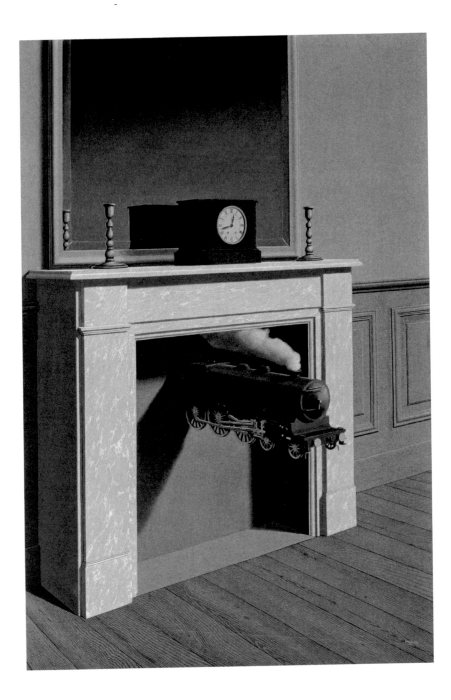

SURREAL FORMS

-

I have spent my life in revolt against convention,
trying to bring colour and light and a sense of
the mysterious to daily existence

-

Eileen Agar

1988

The Surrealists took their pursuit of the marvellous seriously – with a missionary zeal they searched for it in chance encounters and mysterious found objects and sought to create poems, paintings, photographs and assemblages that suggested another plane of reality. Using the motifs, strategies and techniques of Surrealism, artists transformed painting, sculpture, photography, film and design in their quest to revolutionize the way people lived.

PHOTOGRAPHY

American Man Ray was the first Surrealist photographer; others included German Hans Bellmer, Hungarian Brassaï, Americans Lee Miller and Frederick Sommer, Belgians Paul Nougé and Raoul Ubac, and French Jacques-André Boiffard, Claude Cahun and Dora Maar. With darkroom manipulation, close-ups and unexpected juxtapositions, photography proved an adept medium for isolating the surreal image present in the world. Photography's dual status as both document and art strengthened the Surrealist claim that the world is full of erotic symbols and surreal encounters.

Man Ray was a central figure in both popular and high culture in Paris of the 1920s and 1930s. He worked publicly, and successfully, in the seemingly incompatible worlds of the Parisian avant-garde and commercial photography. His photographs were published in both specialist and popular periodicals – from *Vogue* and *Vanity Fair* to *Le Surréalisme au service de la révolution*, *La Révolution surréaliste*, *Variétés* and *Minotaure* – often with images from the same series appearing in both. For Surrealism, as for fashion, the mannequin symbolized woman as object, constructed and manipulated, violating the boundaries of alive and not alive.

-

Man Ray's photographs portray women as exotic creatures, both beautiful and menacing

-

The nudes Man Ray used are those of women with whom he was intimately involved (such as Kiki de Montparnasse and Lee Miller), but in the numerous images of each, the photographer's private obsession with the model is raised from the specific to the general to portray an obsession with the female form and its eroticization in art. Man Ray's photographs are not character studies, but object studies. They reveal his interest in word play, the use of masks and mannequins and portray women as exotic creatures, both beautiful

Man Ray
Anatomies, 1929
Gelatin silver print,
22.6 x 17.2 cm (8⅞ x 6¾ in.)
Museum of Modern Art (MoMA), New York

This is a classic Surrealist work in terms of themes and techniques. The photograph presents an unsettling male/female ambiguity as the neck and chin of a female model unexpectedly turns into a phallic image. The association with Freudian theories is evident: the exposed, vulnerable position of the throat hints at fears of decapitation or castration.

Paul Nougé
La naissance de l'objet (*The Birth of the Object*), 1930
Photograph, 40 x 30 cm
(15¾ x 11⅞ in.)
Huis Marseille,
Amsterdam

A photograph from the series *Subversion of Images*, with its playful sense of the uncanny entwined with language. This was a characteristic Nougé shared with his good friend Magritte, who appears second from the right in this picture.

Claude Cahun
Je tends les bras (*I Reach Out My Arms*), 1932
Photograph, 10.7 x 8.2 cm
(4¼ x 3¼ in.)
Jersey Museum, St Helier

In this performative
**photograph, a rock/
human hybrid comes to
life with a zombie-like
reach forward.**

Dora Maar
Le Simulateur (*The Simulator* or *The Pretender*), 1936
Gelatin silver print, 29.2 x 22.9 cm (11½ x 9 in.)
San Francisco Museum of Modern Art (SFMoMA), San Francisco

Maar was involved with the Surrealists between 1934 and 1937. During that time she made some striking photomontages, including this one, which was exhibited in the 1936 'International Surrealist Exhibition' in London. Here she combined a photograph of an inverted vaulted ceiling with another of a boy. Imagining how disorientating the space would be is intensified when you notice that the boy's eyes have been scratched out.

and menacing. Man Ray's women, whether terrifying or ideal, are always sensual and exotic. His photographs were disseminated across Europe and America and served to break down the distinctions between high and popular art, fashion and culture. Man Ray recognized mass culture as a valuable resource and useful tool for exposure.

Nougé's photographs uncover the strange, surprising and the magical in everyday domestic surroundings

Another example of Surrealist photography is the Belgian poet Paul Nougé's *Subversion of Images* series taken between December 1929 and February 1930, a theatrical set of nineteen photographs that uncovers the strange, surprising and the magical in everyday domestic surroundings (page 106).

Claude Cahun is also known for theatrical photographs, such as *I Reach Out My Arms* (page 107), made in 1932, the year that she met Breton in Paris. They became friends and she became an active participant in Surrealist activity before moving to the Channel Island of Jersey in 1937. She shared with Breton a fierce intellect and mutual respect, an interest in psychology and a commitment to revolutionary politics and art. In *I Reach Out My Arms*, a person, presumably Cahun, hides her body behind a large stone and pokes an arm through a hole, creating a convincing, comic surreal image of a rock/human hybrid.

In the late 1930s Raoul Ubac made a series of complex photomontages about the struggles of Penthesilea, the mythic queen of the Amazons (page 110). He used multiple processes – beginning by photographing his wife and her friend in different poses. Then he subjected the images to successive attacks of solarization – montaging different elements, rephotographing them and resolarizing them. He also used another technique called 'petrification' – combining images by sandwich-printing them slightly off-register (not completely lined up). This gives the images depth, as if in low-relief like a frieze.

Italian-American photographer Frederick Sommer met Man Ray and Max Ernst in California in 1941. Sommer contributed photographs to Surrealist publications *View* and *VVV* and was the only photographer in 'Exposition internationale du surréalisme' in Paris in 1947.

Raoul Ubac
Penthésilée IV, 1937
Gelatin silver print,
29.85 x 40.96 cm
(11¾ x 16⅛ in.)
San Francisco Museum of
Modern Art (SFMoMA),
San Francisco

**Belgian Ubac was active
in the movement during
the late 1930s and
his photographs often
appeared in *Minotaure*.**

Frederick Sommer
Medallion, 1948
Gelatin silver print, 19.2 x
24.3 cm (7⅝ x 9⅝ in.)
Frederick & Frances
Sommer Foundation,
Prescott

In this eerie photograph,
a doll's head attached to
a wooden background
is partially covered with
peeling paint so that it
appears that the two
have merged. The staring
doll appears to be either
emerging from the wood
or being subsumed by it.

FILM

Film was another medium revolutionized by Surrealism, as shocking and absurd images and strange juxtapositions were used to convey irrational, dreamlike states instead of traditional narratives. *The Seashell and the Clergyman* (1927), directed by French avant-garde filmmaker Germaine Dulac from a script by French poet Antonin Artaud, is credited as the first Surrealist film. While Artaud was not pleased with the film, thinking it too literal a dream narrative, others were baffled, and the techniques that Dulac pioneered in her film to convey hallucinatory scenes would be used in later, better known Surrealist films, such as *Un Chien andalou* (*An Andalusian Dog*, 1928) by Spanish Luis Buñuel and Salvador Dalí (above).

Using slow motion, dislocation and montage to great effect, Buñuel and Dalí created one of the most disturbing films ever made. It was based on dreams they had each had – Buñuel had dreamed of a cloud slicing the moon 'like a razor blade slicing through an eye' and Dalí of a hand covered in ants. To their surprise, the silent short film was enthusiastically received when it debuted in Paris.

Luis Buñuel and Salvador Dalí
Un Chien andalou, 1929
Gelatin silver print
10.8 x 13.3 cm (4⅜ x 5¼ in.)
Philadelphia Museum of Art, Philadelphia

The film opens with one of the most shocking images in film – that of a man slicing open a young woman's eye with a razor blade.

Below: Alfred Hitchcock and Salvador Dalí
Spellbound, 1945
Film still, 35 mm film
(black and white, sound)
Dream sequence

Dalí's contribution to the film contains many Surrealist motifs – a man without a face, floating eye balls that turn into curtains that are then cut by a man with a giant pair of scissors, all in a sharp architectural otherworldly setting.

The Parisian Surrealists were in the audience and promptly invited Buñuel and Dalí to join them. The script for *Un Chien andalou* was published in the final issue of *La Révolution surréaliste* in December 1929. Their next collaboration, *L'Age d'or* (*The Golden Age*, 1930), added sound to the nightmarish visions.

Dalí met Walt Disney and began working on the visuals for a short animated film, *Destino*

Surrealism in film soon moved from those playing to purely avant-garde audiences to those aiming to reach more mainstream ones. For instance, New Zealand experimental artist and filmmaker Len Lye made *When the Pie Was Opened* (1941), a surreal government-sponsored film about cookery during rationing in wartime Britain. Dalí took Surrealism to Hollywood with a dream sequence for American film director Alfred Hitchcock's psychological thriller *Spellbound* in 1945 (below). While working on the Hitchcock film, Dalí met Walt Disney and began working on the visuals for a short animated film, *Destino*. Costs spiralled and the project was shelved, until it was rediscovered in 1999, completed and released in 2003.

Alberto Giacometti
Mains tenant le vide, 1934
Plaster, 156.2 x 34.3 x
29.2 cm (61½ x 13⅜ x
11½ in.)
Yale University Art
Gallery, New Haven

**Giacometti modelled the
figure's face on a metal
mask that he had seen
in a Parisian flea market.
A photograph of the
statue by Dora Maar was
included in Breton's book
L'Amour fou (1937).**

Jean (Hans) Arp
Garland of Buds I, 1936
Limestone, 49.1 x 37.5
cm (19⅜ x 14⅞ in.)
Peggy Guggenheim
Collection, Venice

Former Dadaist Arp was a key early Surrealist, taking part in the first Surrealist exhibition in Paris in 1925. He is known for his biomorphic sculptures, like this one, and commented: 'I exhibited with the Surrealists because their rebellious attitude towards "art" and their direct attitude to life were wise, like Dada.'

SCULPTURE

Swiss artist Alberto Giacometti was responsible for masterful pieces of Surrealist sculpture, such as *Woman with Her Throat Cut* (1932), a bronze construction of an insect-like dismembered female corpse, and the artwork opposite, *Mains tenant le vide* (*Hands Holding the Void*, 1934). Both portray the body of the female as inhuman and dangerous. *Mains tenant le vide* brings together two ideas important to many of the Surrealists: the idea of the dehumanizing mask and the idea of the female praying mantis who kills and decapitates the male while copulating (compare with Domínguez's painting on page 74). As such, the strange, sad figure in *Mains tenant le vide* could be the 'killer female', representing the fear of women and death, and the thrill of dangerous sex. For Breton, who wrote about the sculpture in his book *L'Amour fou* (1937), it was 'the emanation of the desire to love and to be loved'.

Others known for their Surrealist sculptures include German–French Jean (Hans) Arp, Romanian Jacques Hérold, American

David Hare, Brazilian Maria Martins (known as Maria), Spanish Joan Miró and English Henry Moore. Maria's exotic Amazonian 'goddesses and monsters' caught Breton's attention in the 1940s in New York. Her best known sculpture from the group, *The Impossible* (1946: below), like *Mains tenant le vide* (*Hands Holding the Void*), embodies the challenges of love and loving, as the union of a male and female figure who are reaching out towards each other is thwarted by the spiky tentacles and claws sprouting from their heads. *The Impossible* was one of two sculptures by Maria exhibited in 'Exposition internationale du surréalisme' in Paris in 1947.

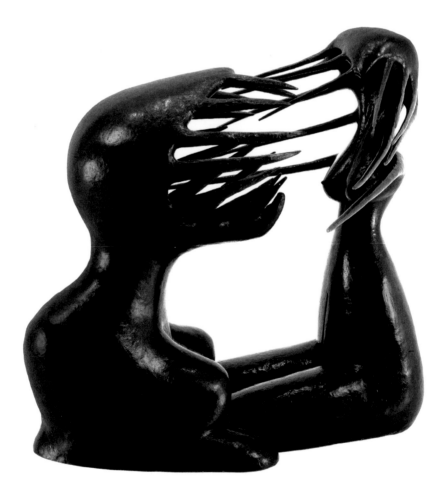

OBJECTS

A particularly popular form of sculpture for the Surrealists was the 'object', and many of the Surrealists made them. Using found objects or cheap materials from junk shops or markets, objects were constructed into assemblages, taking the unusual juxtapositions of collage into three dimensions. They believed that by displacing things from their normal context, we would be able to see them anew – in all their strangeness – and that this would help on the path to re-enchantment. This proved to be a great way to bring together disparate materials to exploit the effects of chance. Many inventive, wacky concoctions allowed the materials to speak for themselves, as well as to create new relationships in conjunction with the other materials, as they are transformed into sculptures, as in Marcel Jean's *Spectre of the Gardenia* (original 1936; page 119).

Man Ray made the first version of his famous metronome with a photograph of an eye attached, *Object to Be Destroyed* (overleaf), in 1923 to keep him company while he painted, as he explained:

> The faster it went, the faster I painted; and if the metronome stopped then I knew I had painted too long . . . One day I did not accept the metronome's verdict, the silence was unbearable and since I had called it, with a certain premonition, *Object of Destruction*, I smashed it to pieces.

A decade later he remade the piece, this time using a photograph of Lee Miller's eye (she had just broken up with him). He included instructions that speak poignantly of his heartbreak:

> Cut out the eye from the photograph of one who has been loved but is seen no more. Attach the eye to the pendulum of a metronome and regulate the weight to suit the tempo desired. Keep going to the limit of endurance. With a hammer well-aimed, try to destroy the whole at a single blow.

The assemblage was destroyed in 1957 by a group of students protesting against a Dada exhibition in which it was included. Man Ray responded by making yet another one, retitling it *Indestructible Object*, and assuring that it lived on: 'I have managed to make them indestructible, that is, by making duplicates very easily.'

When Breton lectured on 'The Surrealist Situation of the Object' in Prague in 1935, he declared that these new forms would 'aid the systematic derangement of all the senses, a derangement recommended by Rimbaud and continuously made the order

Maria Martins
The Impossible, III, 1946
Bronze, 80 x 82.5 x
53.3 cm (31½ x 32½ x
21 in.)
Museum of Modern Art
(MoMA), New York

'I know that my Goddesses and I know that my Monsters will always appear sensual and barbaric to you,' wrote Martins in 1946. Of *The Impossible*, she said: 'The world is complicated and sad – it is nearly impossible to make people understand each other.' This is one of the versions of *The Impossible*; Martins made them in various sizes and materials.

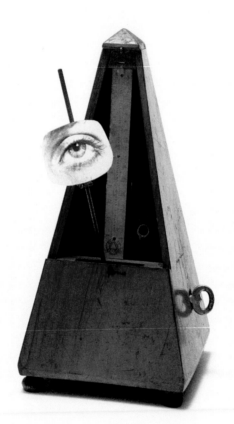

Man Ray
Indestructible Object (or Object to Be Destroyed), 1964 (replica of 1923 original)
Metronome with cut-out photograph of eye on pendulum, 22.5 x 11 x 11.6 cm (8⅞ x 4⅜ x 4⅝ in)
Museum of Modern Art (MoMA), New York

Man Ray wrote about the origin of his metronome in 1923: 'A painter needs an audience, so I also clipped a photo of an eye to the metronome's swinging arm to create the illusion of being watched as I painted.'

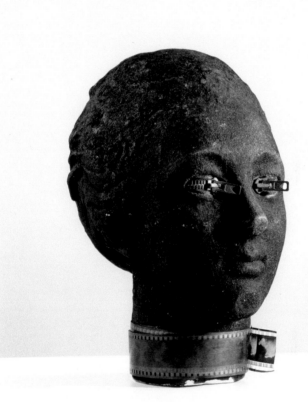

Marcel Jean
Spectre of the Gardenia,
1947 (original made 1936)
Plaster head with painted
black cloth, zips and strip
of film, 35 x 17.6 x 25 cm
(1⅞ x 7 x 9⅞ in.)
Private collection

**For the first version of
his unnerving portrait
head with zipped-up eyes
(1936), Jean used materials
that he found at a flea
market in Paris. It was
exhibited in 'Fantastic Art,
Dada, Surrealism' in New
York in 1936.**

119

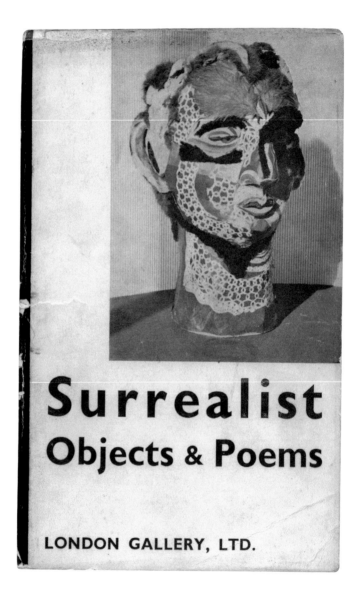

Surrealist
Objects & Poems

LONDON GALLERY, LTD.

of the day by the Surrealists, it is my opinion that we must not hesitate to *bewilder sensation . . .*' Exhibitions dedicated to these assemblages soon followed, notably the 'Exposition surréaliste d'objets' at the Galerie Charles Ratton in Paris in May 1936, 'Surrealist Objects & Poems' at the London Gallery in November 1937 and the 'Exposition internationale du surréalisme' held at the Galerie Beaux-Arts in Paris, January–February 1938 (pages 54–5).

INSTALLATION

From Surrealist exhibitions came the idea of installation as the creative conception of the exhibition as a whole. Sensations were indeed 'bewildered' at the 1938 exhibition at the Galerie Beaux-Arts in Paris and at the 1939 New York World's Fair, where Salvador Dalí's Dream of Venus Pavilion brought Surrealism to the masses (pages 122–3). Dalí's personal underwater fantasy was played out through architecture, sound, performance – and an aquarium! – where Venus's dream was staged underwater by semi-clothed beauties swimming about as mermaids.

-

The visitor purchased a ticket from a fish-head booth and entered through a pair of women's legs

-

From an exterior that looks like an homage to Cheval's Palais Idéal (pages 28–9), the visitor purchased a ticket from a fish-head booth and entered through a pair of women's legs. Once inside, visitors encountered objects and fantastical furniture in rooms with Dalí's trademark paintings turned into wallpaper, including *The Persistence of Memory*, 1931 (pages 96–7). There were also references to past exhibitions, including a new version of his *Rainy Taxi* that had greeted visitors to the 1938 'Exposition internationale du surréalisme' in Paris (page 55), this time with a mermaid on top of it, and Venus herself, asleep on a 11-metre (36-foot) long red satin bed surrounded by *tableaux vivants* of her dreams. One photograph shows a mirror near Venus with the reflection of a woman with a head of roses, surely a fond dream-memory of the 'Phantom of Surrealism' from the 1936 'International Surrealist Exhibition' in London (page 48).

Marcel Duchamp was the great example of the artist as curator and master of ceremonies, planning installations of his own work, and those of others, in minute detail. For the 1942 'First Papers

Eileen Agar
Cover of the catalogue for 'Surrealist Objects & Poems' showing Agar's original 1936 *Angel of Anarchy*, 1937

For her androgynous, uncanny sculpture, Agar covered a plaster head with 'whatever came to hand' – feathers, fur, coloured paper and paper doilies. She explained: 'the title was suggested by the fact that Herbert Read [the exhibition organizer] was known to the Surrealists as a benign anarchist, so that is how I thought of the title "Angel of Anarchy", for anarchy was in the air in the late thirties.'

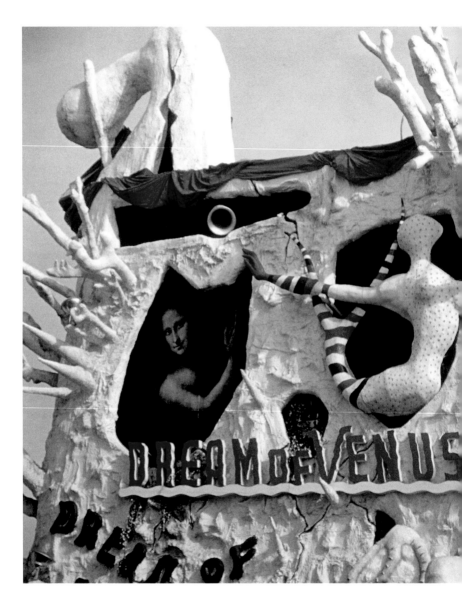

Salvador Dalí
Entrance to the Dream of
Venus Pavilion, New York
World's Fair, 1939

**Dalí's pavilion was his
'Surrealist House' and
his opportunity to invest
architecture with the
sensuality and eroticism
of Surrealism.**

Marcel Duchamp
Sixteen Miles of String, 1942
Installation view
Gelatin silver print by John D. Schiff, 18.6 x 24.6 cm (7⅜ x 9¾ in.)
Philadelphia Museum of Art, Philadelphia

This is Duchamp's installation for the 'First Papers of Surrealism' exhibition, held at the Whitelaw Reid Mansion in New York by the Coordinating Council of French Relief Societies Inc., 14 October– 7 November 1942.

of Surrealism' exhibition in New York, Duchamp constructed a labyrinth of string wound around the screens on which the paintings were installed (pages 124–5). The intervention – *His Twine* (also called *Sixteen Miles of String* and *Mile of String*; 1942) – required viewers actively, not passively, to participate in viewing the works. It built on the 1938 exhibition in which viewers had to take flashlights and really lean in to see the artworks.

Children playing lent a party atmosphere to the exhibition

For the opening reception of the 1942 exhibition, Duchamp also had a group of children weaving in and out of the web of string and playing games, such as hopscotch, baseball, jacks, skipping rope and basketball. Injecting this element of play also gives pause to think about his cat's cradle-like installation as more playful than obstructive. For me, it calls to mind a game played by many generations of my (American) family at children's birthday parties as an icebreaker. Party guests arrive in a room entwined with party streamers; each guest is handed the end of a streamer that they follow over and under furniture and other streamers and guests until they reach the end and a prize. Duchamp's installation and the children playing certainly would have lent a party atmosphere to this important exhibition, which was an introduction for many of the Surrealists-in-exile in New York.

These theatrical interventions in an art environment questioned how art could be displayed and experienced and had an enormous influence on the art and design that followed.

LIVED SURREALISM

Although its poetic and cerebral aspirations may not have been grasped, Surrealism's images captured the public imagination. Its strange juxtapositions, whimsy and dream imagery found its way into everything from the high-fashion designs of Italian Elsa Schiaparelli to applied arts, window-display and advertising for organizations such as London Transport and Shell.

Schiaparelli was inspired by and worked with a number of Surrealists, including Man Ray, Picasso, Dalí and Eileen Agar. In 1936 she designed black suede gloves with red snakeskin fingernails (opposite). Or, if you prefer, you could wear the gloves on your head, as they became part of a new collaboration

Elsa Schiaparelli
Woman's Gloves, 1936–7
Black suede and red snakeskin, 23.8 x 8.6 cm (9⅜ x 3⅜ in.)
Philadelphia Museum of Art, Philadelphia

These gloves were inspired by Man Ray's photograph of a pair of hands painted by Picasso to look like gloves taken in 1935.

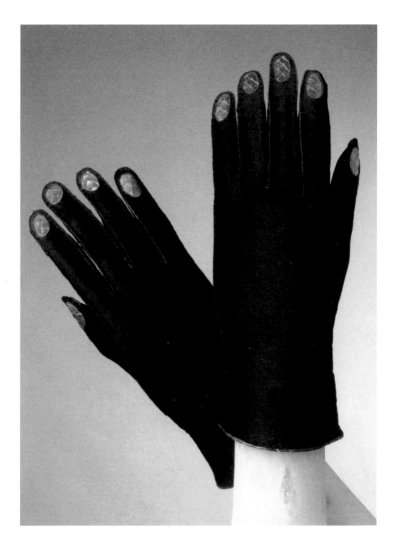

Elsa Schiaparelli
*Tears Evening Dress
and Veil*, 1938
Printed silk crêpe with
cut-outs and appliqués:
front length: 144.8 cm
(57 in.); back length:
105.4 cm (41½ in.)
Philadelphia Museum
of Art, Philadelphia

**Dalí helped his friend
Schiaparelli design the
illusionistic tears for
this dress.**

Oscar Domínguez
*Brouette no. 1
(Wheelbarrow no. 1)*,
before 1937
Wood, felt and satin,
53 x 153 x 61 cm
(20⅞ x 60¼ x 24⅛ in.)
Musée d'art moderne de
la Ville de Paris, Paris

with British Surrealist Eileen Agar in her *Glove Hat* (1936).
Or perhaps you prefer a shoe? Then look no further than *Shoe
Hat* by Schiaparelli and Dalí (1937). Other collaborations with Dalí
included dramatic evening dresses: the 1937 *Lobster Dress*, and the
Skeleton Dress and the *Tears Dress* (with designs that look like flayed
flesh; opposite), both from 1938.

Bringing a bit of unexpected glamour to an everyday object

Oscar Domínguez transformed a wooden wheelbarrow into
an upholstered satin chaise longue (below), which Man Ray used
to photograph a model in an evening dress – bringing a bit of
unexpected glamour to an everyday object and a touch of the absurd
to high fashion. The photograph was published in the Surrealist journal
Minotaure in 1937.

Dalí also made objects and furniture with his great patron,
British Surrealist and poet Edward James. Dalí and James met
in Spain in 1934 and became fast friends and collaborators.
They made the famous *Lobster Telephone* (or *Aphrodisiac Telephone*,
1936; overleaf) and *Mae West Lips Sofa* (1938). Dalí worked in
a variety of media, but common to all his work is an ability to make
arresting associations – such as a lobster and a telephone – which
is, Dalí said, a 'spontaneous method of irrational knowledge'.

Salvador Dalí
Aphrodisiac Telephone,
1938
Plastic and metal,
20.96 x 31.12 x 16.51 cm
(8¼ x 12¼ x 6½ in.)
Minneapolis Institute
of Art, Minneapolis

**This classic of Surrealist
design is one of the
white versions of the
Lobster Telephone that
Dalí and James made in
conjunction with British
interior designer Syrie
Maugham, who was
famous for her all-white
interiors. There are also
a number of versions
featuring a red painted
lobster on a modified
black telephone,
originating in 1936.**

Argentinian artist, designer and writer Leonor Fini also designed Surrealist furniture, such *Corset Chair* and *Armoire anthropomorphe* (*Anthropomorphic Wardrobe*; opposite), both from 1939, which were exhibited in the debut exhibition of decorative arts for the new Drouin Art Gallery in Paris in July. Austrian-American Frederick Kiesler designed Peggy Guggenheim's gallery, Art of This Century, in New York in 1942 as well as the furniture to go in it. His *Multi-use Chair* could be used to sit on (page 102 and below), lean on or display art on. And Italian designer Piero Fornasetti brought Surrealism home, applying Surrealist motifs to ceramics, glass, furniture and textiles. Fornasetti's 'Adam and Eve' set of porcelain plates from the mid-1950s consisted of a dozen plates, each showing a different part of the human body. His work toured America in the early 1950s and he soon became internationally known for his bold graphic black-and-white decorative designs.

Edward James, meanwhile, took his obsession with Surrealism to the Mexican rainforest. On a trip to Mexico in 1945, James was taken to Xilitla, a small mountain village high in the Sierra Madre Orientals, that was to become home to his Surrealist paradise, Las Pozas, a phantasmagorical environment of thirty-six reinforced

Frederick Kiesler
Multi-use Chairs, 1942
Object: oak and linoleum,
84.8 x 39.7 x 88.9 cm
(33⅜ x 15⅝ x 35 in.)
Museum of Modern Art
(MoMA), New York
Photograph taken for
Peggy Guggenheim's
gallery, Art of This
Century, New York, 1942

**Kiesler thought of
eighteen different uses
for these wave-like chairs.**

Leonor Fini
Armoire anthropomorphe,
1939
Oil on wood, 219.7 x
144.8 x 31.8 cm (86½ x
57⅛ x 12⅝ in.)
Weinstein Gallery,
San Francisco

**Fini moved to Paris
in 1932 and quickly
became part of the
Surrealist milieu.**

concrete structures beautifully entwined with the lush vegetation of the tropical rainforest. Although James spent over twenty years, between 1962 and 1984, and more than five million dollars building this concrete Surrealist fantasy, he never completed it.

Artists and designers used Surrealist tactics to reveal an alternative universe of the imagination. They reinstated the power of wonder, mystery and play in order to help artist and audience alike to delight in all its convulsive giddy glory.

KEY MEDIA

Literature

Painting

Photography

Sculpture

Applied arts

Fashion

Advertising

Film

Environments

Installations

Set design

Edward James
Palacio de bambú
(Bamboo Palace)
at Las Pozas (The Pools),
1962–84
Thirty-six reinforced
concrete structures in
twenty acres of tropical
rainforest, Xilitla, Mexico

**Arches, towering columns
and sculptures are at
one with the abundance
of flowers, plants and
trees. James, who Dalí
described as 'crazier
than all the Surrealists
together', also kept a
menagerie at Las Pozas.**

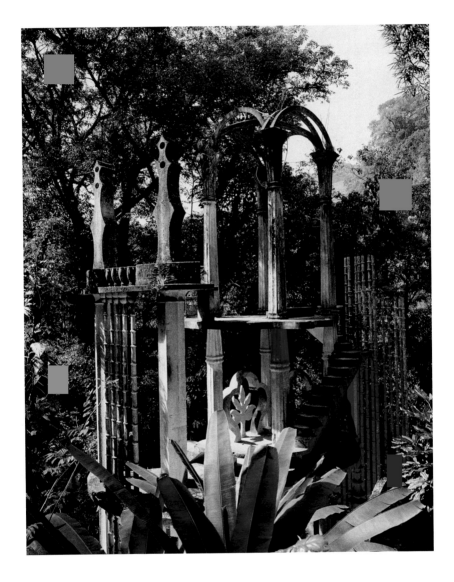

THE SURREALIST REVOLUTION

-

**Surrealism may amuse you,
it may shock you, it may scandalize you,
but one thing is certain:
you will not be able to ignore it**

-

Publicity for 'What is Surrealism?' by André Breton

1936

Dezső Korniss
The Devil, 1947
Oil on canvas, 129 x
50.5 cm (50⅞ x 20 in.)
Private collection

**In his paintings from
1945 to 1948, Korniss
navigates the challenge
of expressing the
post-war era with his
half-human, half-animal
creatures brought to life
in rhythmic stripes of
colour.**

POST-WAR SURREALISMS

The heyday of Surrealism would turn out to be the 1920s and
1930s, as the Second World War revealed new horrors and
atrocities and resulted in a Europe divided into East and West.
New groups embracing Surrealism formed after the war, as artists
searched, yet again, for a way to use their creativity to heal a
ravaged Europe and renew mankind.

In Hungary, the Európai Iskola (European School) was founded
in Budapest in 1945 to defend new artistic developments and to
promote a synthesis between East and West. The group, which
included Margit Anna, Endre Bálint, Béla Bán and Dezső Korniss,
among others, announced in its manifesto: 'We have to create a vital
European school, which formulates the new relationship between
life, man and community.' Korniss, for example, turned to composer
Béla Bartók and artist Pablo Picasso for inspiration: 'One of them
realizes humanity and Europeanism through music, and the other
through painting. Both arts want to express the deepest reality with
all of life's beauty, but also its hell.'

The pre-war Surrealism of Hungarian Lajos Vajda was also an
important model (pages 71–4). The European School organized an
astounding thirty-eight exhibitions in three years, including ones
with Surrealists in Romania, Czechoslovakia and Austria. French
Surrealist Marcel Jean lived in Budapest during the war, became
an honorary member and helped facilitate exchanges between the
group and the French Surrealists, leading to Bán and Bálint being
included in Breton's first post-war Surrealist exhibition in Paris in
1947. The European School disbanded in 1948 when its activities
were banned by official Stalinist cultural policy, although some
members continued to occasionally meet in secret.

In Britain, Surrealist activity increasingly took place in
Birmingham, where a group of artists, including Emmy Bridgwater
and Desmond Morris, gathered around Conroy Maddox. They
sought to reinvigorate British Surrealism. Zoologist, ethnologist and
artist Morris was drawn to Surrealism as part of his youthful rebellion
against the horrors of war:

Desmond Morris
The Jumping Three, 1949
Oil on canvas, 77.3 x 127.1
cm (30½ x 50⅛ in.)
Birmingham Museum and
Art Gallery, Birmingham

**In 1950 Morris shared his
first London exhibition
of Surrealist paintings
with Joan Miró in a show
organized by Belgian
Surrealist E. L. T. Mesens.
Since that time, he has
made more than 2,500
Surrealist paintings and
directed two Surrealist
films. He is known for
his meticulously
painted dreamlike
scenes inhabited by
biomorphic forms.**

> I had to rebel, but . . . my rebellion could not be a destructive
> one – after all I was rebelling against mass violence and hatred,
> so my rebellion had to be of some other, more positive kind . . .
> My artistic rebellion took the form of turning my back on
> accepted, traditional art and associating myself instead with
> the Surrealists.

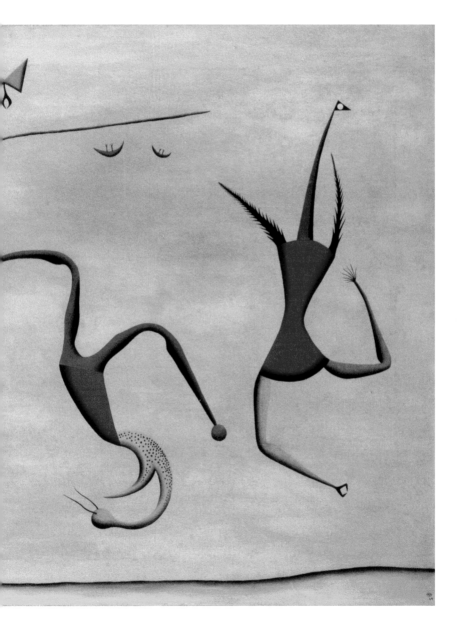

He moved to Birmingham in 1948 and, as Morris wrote, 'found a thriving Surrealist group centred on the home of the painter Conroy Maddox. Perhaps painter is the wrong word for him – he was a theorist, an activist, a pamphleteer and a writer, as well as an artist – in fact the total Surrealist.' The Birmingham Surrealists formed strong relationships with their continental counterparts and Maddox and Bridgwater were included in Breton's first post-war Surrealist exhibition in Paris in 1947.

Meanwhile, in Sweden, the Imaginisterna (the Imaginists) was formed in Malmö by C. O. Hultén, Anders Österlin and Max Walter Svanberg in 1945. Stressing the importance of the imagination in the creative process, they used Surrealist styles and techniques, such as *frottage*, collage, decalcomania and photograms. For Svanberg, Imaginism was 'based on continuously unfolding images, progressively shocking by sucking the spectator into the vision and into imaginative thinking'.

In 1947 the group started its own publishing house, Image Förlag, and published Hultén's *frottage* book *Drömmar ur bladens händer* (*Dreams Out of the Hands of the Leaves*). It was the first printed artist's book published in Sweden. In 1947 Hultén also spent time in Paris, where he met Breton and other Surrealists, and visited Cheval's Palais Idéal (see page 28), which greatly impressed him. The group took part in a Surrealist exhibition held at the Expo Aleby in Stockholm in 1949, which also included work by other international Surrealists, including Danish Wilhelm Freddie, Romanians Victor Brauner and Jacques Hérold, German-French Jean (Hans) Arp, German Max Ernst and French Yves Tanguy. The group dissolved in 1956.

The Dau al Set group was particularly concerned with the subconscious, the occult and magic

In Spain the Dau al Set (Catalan: seven-sided die) group was established in 1948 in Barcelona by writers and artists, including Joan Brossa, Modest Cuixart, Joan Ponç and Antoni Tàpies, who wanted to revive the Catalonian contemporary art scene after the damage caused by the Spanish Civil War. They were inspired by Dada and Surrealism, especially the art of Joan Miró and Paul Klee. Tàpies met Miró in 1948 and the two became lifelong friends. The group was fascinated with the subconscious, the occult and magic, and was active until 1956. The artists spread their ideas and work through a magazine of the same name, which they published in Catalan, Spanish and French.

C. O. Hultén
En tromb av imaginationer, (*Tornado of Imaginations*), 1948
Gouache and mixed media, 58 x 66 cm (22⅞ x 26 in.)
Private collection

In contrast to the figurative Surrealism of most of the pre-war Scandinavian Surrealists, Hultén and his associates practised a more abstract, expressive strain of Surrealism arrived at by using automatic techniques. This painting is a typical Imaginist painting – emotive, expressive, wild and imaginative.

Overleaf: Antoni Tàpies
Parafaragamus, 1949
Oil on canvas, 89 x 116 cm (35⅛ x 45¾ in.)
Collection Fundación Antoni Tàpies, Barcelona

When Tàpies joined the Dau al Set group in 1948, he began exploring his interests in Surrealism, psychoanalysis and science. Tàpies's Surrealist phase lasted until about 1952, when he moved on to more abstract work.

SURREALISM RETURNS TO PARIS

André Breton returned to Paris in 1946 to renew Surrealist activity there. However, he found the movement under attack from former members, such as Tristan Tzara, and the leader of the new avant-garde of existentialism, the philosopher Jean-Paul Sartre, who damned it for 'its pretty stupid optimism'. Despite this, major Surrealist exhibitions were held in Paris in 1947 and 1959.

**Breton sought to formulate a new creative rebirth –
one based on myth and mythical thinking**

While in exile during the war, Breton had been investigating the art of magic and the occult in his lifelong quest for the marvellous and search for universal symbolism. He wanted to harness the creative energy and mystery of magic as he sought to formulate a new creative rebirth – one based on myth and mythical thinking. This emphasis was reflected in the Paris homecoming exhibition of 1947, in which he sought to demonstrate Surrealism's continuing relevance to the new post-war reality by elaborating on a 'new myth' of magic and art.

'Exposition internationale du surréalisme' was presented by Breton and Marcel Duchamp at the Galerie Maeght. The exhibition included eighty-seven artists from twenty-four countries and was intended as a display of the movement's continuing internationalism and strength. In the introduction to the catalogue, Breton wrote of Surrealism's connections with an alternative timeless tradition in art and literature. The first image in the catalogue was a work by Haitian painter and Vodun priest Hector Hippolyte, who had been brought into the Surrealist fold; the dreamlike quality of his magic-realist paintings had captured the imagination of Breton and Wifredo Lam on a visit to Haiti in 1945.

As for the previous exhibitions Breton and Duchamp had prepared together in 1938 (Paris; see pages 54–5) and 1942 (New York; see pages 121–6), they designed a complex installation to introduce the public to Surrealism's 'New Myth'. With the help of Austrian-American architect and artist Frederick Kiesler, the gallery was transformed into a labyrinth of rooms that evoked a ceremonial rite of initiation. Kiesler called his design 'magic architecture', an environment which could mediate between dream and reality. He also directed the installation of the exhibition, choreographing a total experience.

Frederick Kiesler
Conceptual drawing for Salle Superstition (Hall of Superstition), 1947
Pen and black ink and opaque watercolour on cream board, 37.8 x 50.5 cm (14⅞ x 19⅞ in.)
Philadelphia Museum of Art, Philadelphia

Architect, artist and visionary Kiesler designed the Hall of Superstitions for the 'Exposition internationale du surréalisme', organized by Marcel Duchamp and André Breton at the Galerie Maeght in Paris in 1947.

Frederick Kiesler
Totem for All Religions, 1947
Wood and rope,
285.1 x 86.6 x 78.4 cm
(9 ft 4¼ x 34⅛ x 30⅞ in.)
Installation photograph by
Willy Maywald at
'Exposition internationale
du surréalisme', Galerie
Maeght, 1947

**Kiesler's first sculpture
stands more than
nine feet tall (274
cm), attempting to
protect all religions
from superstition and
prejudice.**

Enrico Donati
Evil Eye, 1947
Mixed media,
24.8 x 28.9 x 17.8 cm
(9⅞ x 11½ x 7⅛ in.)
Philadelphia Museum
of Art, Philadelphia

Donati's eerie sculpture
stared down at visitors
to the exhibition from a
special place on the wall.
The photograph opposite
shows how it was installed
above Kiesler's sculpture
(top left corner).

Jacques Hérold
Le Grand Transparent,
1947–64
Plaster, 183 x 92 x 53 cm
(72⅛ x 36¼ x 20⅞ in.)
Centre Pompidou, Paris

Breton was a great
fan, proclaiming:
'Jacques Hérold, his
fingers speckled with
phosphorus, over a forest
of radiolaria. Jacques
Hérold, the woodcutter
in every drop of dew.'

The first stage involved ascending a tarot staircase with steps that looked like the spines of books from a Surrealist 'ideal library'. A miniature revolving lighthouse beckoned from the landing above, guiding the viewer to Kiesler's Hall of Superstitions. The cave-like space had walls covered with dark-turquoise fabric and was lit with yellow and blue lights (page 147). Uncanny objects and artworks in the room included *Black Lake* by Max Ernst painted on the floor, American David Hare's *Anguished Man*, Joan Miró's *Cascade of Superstitions*, Kiesler's *Totem for All Religions* (page 148) and Italian–American Enrico Donati's *The Evil Eye*, a spooky sculpture hung high on the wall (pages 148 and 149).

After facing their fears, the viewer then moved on to Duchamp's Rain Room. This room of purification featured colourful curtains of artificial rain, fake grass on the floor, a billiard table with Maria Martins's bronze sculpture *The Impossible* (page 116) on it and artworks by Lam, Miró and others. This provided a touch of humour and playfulness before moving on to the Labyrinth of Initiation, which was designed by Duchamp and guarded by Romanian Jacques

Victor Brauner
Loup-table, 1939–47
Wood and parts of stuffed fox, 54 x 57 x 28.5 cm
(21⅜ x 22½ x 11¼ in.)
Centre Pompidou, Paris

The inspiration for this snarling table came from two of Brauner's paintings in which he included an angry fox looming out of a table.

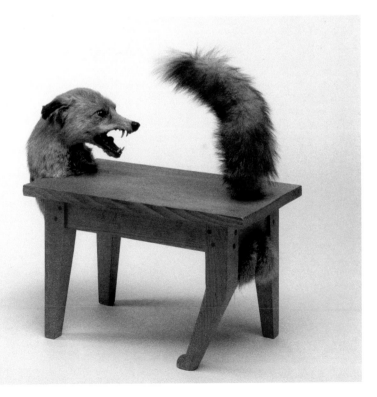

Hérold's imposing life-sized figure *Le Grand Transparent* (*The Great Transparent One*; page 150). Hérold, who had joined the Surrealists in Paris in 1938, made the sculpture for the exhibition as requested by Breton. It is based on a concept of Breton's about invisible beings living among us, who 'mysteriously reveal themselves to us when we are afraid and when we are conscious of the workings of chance'.

This room had twelve altars in octagonal niches, each created by an artist for a magical object or creature and a sign of the zodiac. One of the altars featured Romanian Victor Brauner's *Loup-table* (*Wolf-table*; 1939–47), also made especially for the exhibition (page 151). Brauner had joined the Surrealists in Paris in 1933. His hybrid creature – part snarling wolf, part furniture – made its first appearance in two of his paintings of 1939, *Fascination* and *Psychological Space*. Breton asked him to make it into a three-dimensional object for the 1947 exhibition. The final room was a 'Library' of books, pictures and mementoes.

The exhibition was a popular success – attracting some forty thousand visitors – although many critics saw it as the beginning of the end for the movement. A slightly smaller version of the 1947 Paris exhibition travelled to Prague and Santiago, Chile, in 1948.

The play on words turns on the fact that you are not normally allowed to touch a breast or an art object

As to be expected, the catalogue was a provocative artwork in its own right. The limited-edition print run of 999 copies featured a special cover by Donati and Duchamp with a hand-painted foam and rubber breast (known as a 'falsie') on a circle of black velvet, which was then glued on to the cardboard slip cover along with a sign that said '*Priere de Toucher*' (*Please Touch*), the play on words turning on the fact that you are not normally allowed to touch a breast or an art object (opposite).

Donati had met Breton and Duchamp in New York in 1942. Breton pronounced him a Surrealist and proclaimed, 'I love the paintings of Enrico Donati as I love a night in May.' Donati recalls:

I was just a kid, . . . but Breton accepted me into the Surrealist movement. Suddenly I was surrounded by giants – Max Ernst, Tanguy, all of the big guys. Matta and I were the youngest of this group of the most impossible characters. But we got along very well.

Marcel Duchamp and Enrico Donati
Prière de Toucher, 1947
Book with collage of foam rubber, pigment, velvet and cardboard adhered to removable cover, cover: 23.5 x 20.5 cm (9⅜ x 8⅛ in.)
Philadelphia Museum of Art, Philadelphia

Donati recalled a conversation he had with Duchamp during the laborious process of making the covers: 'I remarked that I had never thought I would get tired of handling so many breasts, and Marcel said, "Maybe that's the whole idea".'

Louise Nevelson
Chinese Landscape, 1959
Wood and pigment,
130.8 x 57.5 x 8.9 cm
(51½ x 22¾ x 3⅝ in.)
Minneapolis Institute of
Art, Minneapolis

**Nevelson would assemble
sculptural murals from
reclaimed wood and paint
them a uniform colour,
usually black or white.**

THE LEGACY OF SURREALISM

By the 1959–60 'Exposition inteRnatiOnale du Surréalisme' (EROS), held at the Galerie Daniel Cordier in Paris, Surrealism was no longer a centrally organized world movement, but a loose federation of autonomous national groups and individuals, including the young Americans Robert Rauschenberg, Jasper Johns and Louise Nevelson. While Surrealism was criticized in these post-war exhibitions for being a spent force, too optimistic and apolitical, too fashionable and appealing to the bourgeoisie, it had a profound influence on the art that followed and on public taste. The Surrealists' efforts to turn the 'marvellous' of everyday objects into a shared public language was an important source of inspiration for many artists, such as Nevelson. From the mid-1950s she produced her first series of black wood landscape sculptures, created using wood that she scavenged from the streets of New York, as in *Chinese Landscape* (1959; opposite).

-

Like the Surrealists, CoBrA wanted to escape the 'civilizing' influences of art and society discredited after the war

-

Overleaf: Karel Appel
Hip, Hip, Hoorah!, 1949
Oil on canvas, 81.7 x 127 cm (32¼ x 50 in.)
Tate Modern, London

Appel deliberately mimicked the look and feel of child and folk art in order to capture their spontaneity and freedom of expression. He called the boldly coloured hybrid creatures in this painting 'people of the night', and the celebratory title came to him because of the artistic freedom that he felt: 'something fantastic was happening. I made the painting and I said "hip, hip, hoorah".'

Surrealism's ideas and techniques influenced many of the post-war art movements. Its automatism and spontaneity could be seen as leading to the all-over paintings of Jackson Pollock and the gestural artists of Abstract Expressionism and Art Informel, while others, such as the Beat artists, Neo-Dadaists, Nouveaux Réalistes and Fluxus artists, drew on Surrealism's flair for theatricality, appreciation of the 'marvellous' in the everyday and use of collaborative practices.

The artworks of Dutch Karel Appel and Danish Asger Jorn are indebted to Surrealism (overleaf and page 159). Both were members of CoBrA, an international collective of primarily northern European artists who joined together from 1948 to 1951 to promote their vision of a new art for the people that could express both the horror and humour of reality. The name is derived from the first letters of their hometowns – Copenhagen, Brussels and Amsterdam. Like the Surrealists, they wanted to unleash the unconscious and escape the 'civilizing' influences of art and society discredited after the war.

The meticulous realism and sly humour of Magritte and Dalí looks forward to Pop and Super-realism, while the use of the found object, interest in installation and of the conception of the exhibition as a whole has been explored by numerous artists since. Surrealism's

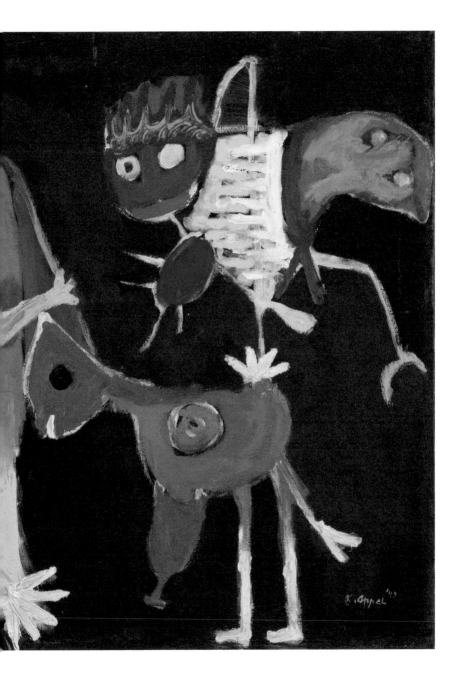

internationalism, its creation of an 'imaginary museum' of ancestors and its embracing of optimism over pessimism are also important aspects of the movement that have continued to be developed.

By the time Breton died in 1966, Surrealism had left an indelible mark on both popular culture and high culture, and the word 'surreal' had become an ordinary part of day-to-day life and vocabulary. On hearing of his friend's death, Duchamp said:

> I have never known a man who had a greater capacity for love. Breton loved like a heartbeat. And you cannot understand anything about his hatreds if you don't realize he acted in this way to protect his love for life, for the marvellous in life. He was the lover of love in a world that believes in prostitution.

Asger Jorn
Untitled, 1954
Ceramic, 32.5 x 26 x
4 cm (12⅞ x 10¼ x 1⅝ in.)
Donation Jorn, Silkeborg

This is from the period in Jorn's career when he was particularly interested in experimenting with various materials and space via ceramics and architecture. He was also seeking to reinterpret aspects of Nordic folk culture to reflect the times in which he was living.

KEY QUOTATIONS

'The thoroughgoing, exalting, unique spirit of Breton and his friends, their whole approach to life and the world, and the tone of certainty and supreme defiance that accompanied it: all this fulfilled me, liberated me, and instilled in me a joy such as I suspect young people today can scarcely grasp . . .' Jacqueline Lamba, 1974

'We were nothing, just a small group of insolent intellectuals who argued interminably in cafés and published a journal; a handful of idealists easily divided where action was concerned. And yet my three-year sojourn in the exalted – and yes, chaotic – ranks of the movement changed my life.' Luis Buñuel, 1982

'The work of Surrealism can never be conclusive. It is more of an exploration ... and a struggle... I will remain on my quest for surrealism until my last breath.' Conroy Maddox

'The impact of the Surrealist philosophy left a lasting impression on all of us who fell under its spell.' Desmond Morris

'The Surrealists, thank goodness, believed in a sense of humour – jokes, everything that was lively, a bit different.' Eileen Agar, 1988

KEY COLLECTIONS

Arp Museum Bahnhof Rolandseck, Remagen, Germany
Arp Foundation, Clamart, France
Art Institute of Chicago, Chicago, IL, USA
Centre Pompidou, Paris, France
Dalí Theatre-Museum, Figueres, Spain
Farleys House & Gallery, Chiddingly, Sussex, England, UK
Fundació Joan Miró, Barcelona, Spain
Govett-Brewster Art Gallery/Len Lye Centre, New Plymouth, NZ
Hyogo Prefectural Museum of Art, Kobe, Japan
Israel Museum, Jerusalem, Israel
Janus Pannonius Museum, Pécs, Hungary
Jersey Museum and Art Gallery (C. Cahun), St Helier, Jersey, CI
Max Ernst Museum, Brühl, Germany
The Menil Collection, Houston, TX, USA
Metropolitan Museum of Art, New York, NY, USA
Minneapolis Institute of Art, Minneapolis, MI, USA
Mjellby Art Museum, Halmstad, Sweden
Musée Cantini, Marseille, France
Musée Magritte, Brussels, Belgium
Musée National d'Art Moderne de la Ville de Paris, Paris, France
Museo de Arte Moderno (INBA), Mexico City, Mexico
Museo Nacional Centro de Arte Reina Sofia, Madrid, Spain
Museu Coleção Berardo, Lisbon, Portugal
Museum Boijmans Van Beuningen, Rotterdam, Netherlands
Museum of Modern Art (MoMA), New York, NY, USA
National Gallery of Canada, Ottawa, Canada
Paul Delvaux Museum, St Idesbald, Belgium
Peggy Guggenheim Collection, Venice, Italy
Philadelphia Museum of Art, Philadelphia, PA, USA
Las Pozas (Edward James), Xilitla, Mexico
René Magritte House Museum, Brussels, Belgium
Salvador Dalí Museum, St Petersburg, FL, USA
São Paulo Museum of Modern Art, São Paulo, Brazil
Scottish National Gallery of Modern Art, Edinburgh, Scotland, UK
Smithsonian American Art Museum, Washington, DC, USA
Solomon R. Guggenheim Museum, New York, NY, USA
Tate Modern, London, England, UK
Tenerife Espacio de las Artes, Santa Cruz, Tenerife, Canary Islands
Trade Fair Palace, Prague, Czech Republic
Vajda Lajos Museum, Szentendre, Hungary
Wadsworth Atheneum Museum of Art, Hartford, CT, USA
Yale University Art Gallery, New Haven, CT, USA

Niki de Saint Phalle
The World (tarot card no. XXI), 1989, height: 5 m (32 ft 10 in.)
Wire mesh, iron, concrete and mosaic of mirrors and coloured glass
Il Giardino dei Tarocchi (Tarot Garden), 1998 Pescia Fiorentina, Tuscany

Franco-American Saint Phalle was a member of the Nouveaux Réalistes in the late 1950s and 1960s. Like the Surrealists, they were a loose cluster of artists of diverse backgrounds and nationalities who shared a similar attitude towards art and life. In 1978 she began realizing her vision of a sculptural environment based on tarot symbols. By bringing together sculpture, architecture, nature, poetry, narrative, and yes, a little bit of magic, she created a place that is more like another world than a sculpture garden.

Yayoi Kusama
Infinity Mirror Room –
Phalli's Field, 1965
Installation, mixed media
R. Castellane Gallery,
New York, 1965

**Avant-garde Japanese
artist Kusama (pictured
in the photograph)
began using mirrors in
1965 to help her achieve
the repetition crucial
for her artworks that
explore the infinite and
the otherworldly. In her
various *Infinity Mirror
Rooms*, it is as if you,
the viewer, have stepped
inside a kaleidoscope.
There you are endlessly
reflected and immersed
in a fantastical world, in
this case, one filled with
surreal soft-sculpture
phallic forms covered
with Kusama's signature
polka dots. Your senses
are disordered by an
experience that is
hallucinatory, magical –
and marvellous!**

GLOSSARY

Abstract Expressionism: refers to paintings by a group of US-based artists prominent during the 1940s and 1950s, including Willem de Kooning, Jackson Pollock and Mark Rothko. They felt that the true subject of art was man's inner emotions and used gesture, colour, form and texture for their expressive and symbolic potential.

Applied art: functional objects designed and decorated to make them artistic as well as functional; includes glass, ceramics, textiles, furniture, printing, metalwork and wallpaper.

Art Deco: art and design movement of the 1920s and 1930s characterized by the use of simplified forms, bold patterns and strong colours. Its exuberance and fantasy captured the spirit of the Roaring Twenties and provided an escape from the realities of the Depression during the 1930s.

Art Informel: one of the names used in Europe for the expressive gestural abstract painting that dominated the international art world from the mid-1940s until the late 1950s.

Assemblage: sculpture that is constructed rather than modelled or carved. Often incorporates non-art materials. Collage taken into three dimensions.

Automatism: a spontaneous method of writing or painting when the writer or artist is not consciously thinking about what they are doing.

Avant-garde: ahead of one's contemporaries – experimental, innovative, revolutionary.

Beat Art: the Beat Generation encompassed a variety of avant-garde writers, visual artists and filmmakers around the United States in the 1950s. What they shared was a contempt for conformist, materialist culture and a refusal to ignore the dark side of American life.

Brûlage: (burning or singeing) a photographic method invented by Raoul Ubac. He would melt the emulsion on an exposed negative by placing it over a pan of heated water before printing it.

Cadavre exquis (exquisite corpse): a collaborative way to write or draw. A person writes or draws on a piece of paper, folds it so that it cannot be seen and passes it on to the next person, who then adds another fragment before passing it on. Used by the Surrealists to reach the collective unconscious and create surprising juxtapositions.

Collage: a technique in which mixtures of different pre-existing materials are stuck on to a flat surface to create a work of art.

Dada: an international, multi-disciplinary art movement that developed during and after the First World War, as young artists banded together to express their anger with the war. They challenged the status quo via satire, irony, games and word play.

Decalcomania: (to transfer) a method of painting used by a number of Surrealists. Paint is spread on a piece of paper and another is pressed on top of it while the paint is still wet. The top piece is lifted off just before the paint dries to reveal transfer images.

Existentialism: the most popular philosophy of post-war Europe. It posited that man is alone in the world without any pre-existing moral or religious systems to support and guide him. On the one hand, he is forced to a realization of his solitariness, of the futility and absurdity of existence; on the other, he has the freedom to define himself, to reinvent himself with every action.

Fluxus: an anarchic, playful, experimental, international art group of the 1950s and 1960s. Fluxus artists sought a closer integration of art and life and a more democratic approach to making, receiving and collecting art.

Found object: man-made or natural non-art objects or materials found by an artist that are then incorporated into artworks or designated artworks.

Free association: saying what comes to mind to a stimulus (word or image) immediately without filtering or censoring one's response. A method used in psychoanalysis to reach the unconscious.

Frottage: (rubbing) a piece of paper is placed over a textured surface and interesting marks are revealed by rubbing a pencil or crayon over the paper.

Fumage: (smoking) a technique using smoke from a candle to 'draw' shapes. A candle is quickly grazed over sheet of paper or prepared canvas leaving sooty marks, which are then worked over by the artist.

Grattage: (scraping) a canvas, prepared with a layer of oil paint, s placed on a textured surface or object. The paint is then scraped away to create an interesting and unexpected surface.

Happening: 'Something to take place; a happening', announced the American artist Allan Kaprow in 1959. Happenings combined elements of theatre and gestural painting.

Installation: a mixed-media construction or environment that engages with its surrounding space and incorporates viewers into the work.

Magic Realism: a style of painting popular from the 1920s to 1950s in the United States and Europe. Works are characterized by a meticulous, almost photographic rendering of realistic-looking scenes endowed with mystery and magic through ambiguous perspectives and strange juxtapositions.

Manifesto: a published declaration of intention, mission and vision.

Marxism: economic, social and political system based on principles developed by Karl Marx in the mid-nineteenth century. A central tenet is that there should be public ownership of the means of production and distribution. Another is the belief that class struggle between the ruling classes and the oppressed would eventually lead to a socialist classless society. Later developed by followers into the foundation of Communism.

Metaphysical painting: the name given to the style of painting developed from around 1913 by Giorgio de Chirico. Distorted perspectives and juxtapositions of incongruous objects were used to create pictures with a disquieting air of mystery.

Modernism: a belief that art should reflect modern times. Successive groups of artists experimented with alternative ways to make art, breaking with the classical traditions taught since the Renaissance. In the visual arts, Modernism revolutionized ways of conceiving and perceiving the artistic object.

Neo-Dadaists: a group of young American experimental artists whose work attracted fierce controversy in the late 1950s and 1960s. For Robert Rauschenberg, Jasper Johns and Larry Rivers, art was to be expansive and inclusive, appropriating non-art materials, embracing ordinary reality and celebrating popular culture.

Nouveaux Réalistes: a group of European artists, including Yves Klein, Daniel Spoerri, Jean Tinguely, Arman and others, founded by the French art critic Pierre Restany in Paris in 1960. They took great pleasure in exploring different processes of making art and using unusual materials.

Photograms: early photographs made without a camera, which were usually created by placing objects on light-sensitive paper and leaving them outside.

Pop Art: a popular international art movement that emerged in the 1950s and was at its height in the 1960s. Artists were interested in popular culture and sought to make art out of it, using images from advertising, mass media and daily life as both source material and subject matter.

Psychoanalysis: theories and techniques founded by Sigmund Freud to study the unconscious mind in order to understand and cure mental health problems.

Rayographs: photographs made by placing an object directly onto photographic paper, which is then exposed to light without using a camera.

Readymade: name used by Marcel Duchamp for certain kinds of found objects used or exhibited by artists with little or no modification by the artist.

Romanticism: late eighteenth- and early nineteenth-century international intellectual movement that celebrated the power of the imagination, individuality and subjectivity. Human psychology, heightened emotions and the power of nature were emphasized.

Super-realism: a particular type of painting and sculpture that became prominent during the 1970s, especially in the United States. Most of the paintings copy photographs and many of the sculptures are constructed from body casts.

Symbolism: international movement that originated in France in 1886. Artists declared the inner world of mood and emotions, rather than the world of external appearances, to be the proper subject of art. Common themes occur, such as dreams and visions, mystical experiences, the occult, the erotic and the perverse, with the goal of creating a psychological impact.

Vodun: a major Haitian religion based on ritual and magic, which fuses aspects of traditional African religions with Roman Catholicism.

FURTHER READING

Ades, Dawn (ed.), *Dada and Surrealism Reviewed* (Hayward Gallery, London, 1978)

Ades, Dawn et al., *The Surrealism Reader: An Anthology of Ideas* (Tate Publishing, London, 2005)

Ades, Dawn et al., *Surrealism in Latin America* (Tate Publishing, London, 2013)

Alison, Jane (ed.), *The Surreal House* (Yale University Press/Barbican Art Centre, New Haven, CT/London, 2010)

Bardaouil, Sam, *Surrealism in Egypt: Modernism and the Art and Liberty Group* (I. B. Tauris, London, 2016)

Breton, André, *Manifestoes of Surrealism*, translated by Richard Seaver and Helen R. Lane (University of Michigan Press, Ann Arbor, MI, 1969)

Caws, Mary Ann, *Surrealism* (Phaidon, London, 2010)

Chadwick, Whitney, *The Militant Muse: Love, War and the Women of Surrealism* (Thames & Hudson, London, 2017)

'From Dada to Infra-noir: Dada, Surrealism, and Romania', *Dada/Surrealism*, Number 20 (2015; International Dada Archive, University of Iowa Libraries, Iowa, IA), online journal: http://ir.uiowa.edu/dadasur/vol20/iss1

Kieselbach, Tamás (ed.), *Modern Hungarian Painting 1919–1964* (Kieselbach Tamás, Budapest, 2004)

King, Elliott H., *Dalí, Surrealism and Cinema* (Kamera Books, Harpenden, 2007)

Krauss, Rosalind and Jane Livingstone, *L'Amour fou: Surrealism and Photography* (Abbeville Press, New York, NY, 1987)

Millroth, Thomas, *CO Hultén, The Years of Anticipation 1944–1955* (Galerie Bel´Art, Stockholm, 2008)

Morris, Desmond, *Sixty-Nine Surrealists* (Dark Windows Press, Rhos on Sea, 2017)

Morris, Desmond, *The Lives of the Surrealists* (Thames & Hudson, London, 2018)

Rosemont, Penelope (ed.), *Surrealist Women: An International Anthology* (University of Texas Press, Austin, TX, 1998)

1921
· Man Ray accidentally invents rayographs.

1924
· Paris: André Breton launches the Surrealist movement with the publication of the *Manifesto of Surrealism* and *La Révolution surréaliste*.
· The Bureau of Surrealist Research is opened.
· Jacques-André Boiffard, Max Ernst, Man Ray, Antonin Artaud, André Masson and Joan Miró are among the first members of the group.

1925
· Paris: First exhibition of Surrealism, 'Exposition, La Peinture Surréaliste', opens at Galerie Pierre in Paris, at midnight on 13 November. It includes work by Giorgio de Chirico, Hans Arp, Max Ernst, Paul Klee, Man Ray, André Masson, Joan Miró, Pablo Picasso and Pierre Roy.
· 'Exquisite Corpse' technique is invented by the group.
· Max Ernst makes his first *frottages*.
· Yves Tanguy joins the Surrealists.

1926
· Paris: Galerie Surrealist opens with 'Pictures by Man Ray and Objects from the Islands'.
· Brussels, Belgium: Belgian Surrealist group is formed.

1927
· Germaine Dulac directs the first surrealist film, *The Seashell and the Clergyman*.
· André Masson makes his first sand paintings.

1928
· André Breton publishes *Nadja* and *Surrealism and Painting*.
· Salvador Dalí and Luis Buñuel make the film *Un Chien Andalou*.

1929
· Paris: 'Second Manifesto of Surrealism' is published in *La Révolution surréaliste*.
· Scandinavia: Surrealism is introduced in Denmark and Sweden.
· Max Ernst produces his first collage-novel.
· Man Ray and Lee Miller accidentally invent solarization.
· Lee Miller, Salvador Dalí and Luis Buñuel join the Surrealists.

1930
· Paris: Salvador Dalí and Luis Buñuel's second film, *L'Âge d'or*, is screened at the Montmartre cinema, Studio 28. The film is banned by the police.
· Alberto Giacometti joins the Surrealists.

1931
· Hartford, CT, USA: 'Newer Super-Realism', Wadsworth Atheneum is the first large-scale Surrealist exhibition in America.

1932
· Claude Cahun joins the Surrealists.

1933
· Eileen Agar, Meret Oppenheim and Victor Brauner join the Surrealists.

1934
· Brussels, Belgium: 'Minotaure', Palais des Beaux-Arts, first large-scale exhibition of Surrealist works from all over Europe.
· Prague, Czechoslovakia: Czech Surrealist group formed.
· Hans Bellmer, Oscar Domínguez and Dora Maar join the Surrealists.

1935
Copenhagen, Denmark: 'Kubisme-Surrealisme', Den Frie Centre of Contemporary Art
Prague, Czechoslovakia: 'Exposition internationale du surréalisme', Mánes Gallery
Santa Cruz, Tenerife: 'Universal Surrealism Exhibition', Santa Cruz Athenaeum
Wolfgang Paalen joins the Surrealists.

1936
Paris: 'Exposition surréaliste d'objets', Galerie Charles Ratton
London: The British Surrealist group is formed. 'International Surrealist Exhibition', New Burlington Galleries
New York: 'Fantastic Art, Dada, Surrealism', Museum of Modern Art
Oscar Domínguez pioneers 'decalcomania'.
Wolfgang Paalen invents *fumage*.

1937
Paris: André Breton publishes *L'Amour fou* (*Mad Love*).
London: 'Surrealist Objects & Poems', London Gallery
Japan: 'Exhibition of Overseas Surrealist Works', Tokyo, Osaka, Kyoto and Nagoya
Roberto Matta, Remedios Varo and Leonora Carrington join the Surrealists.

1938
Paris: 'Exposition internationale du surréalisme', Galerie Beaux-Arts
Jacques Hérold joins the Surrealists.

1939
European Surrealists begin to flee to the USA and Mexico to avoid Nazi persecution with the onset of the Second World War.
Cairo, Egypt: Art and Liberty Group is formed.

1940
· Bucharest, Romania: Romanian Surrealist group is formed.
· Mexico City, Mexico: 'Exposicion Internaciónal del Surrealismo', Galeria de Arte Mexicano
· Wifredo Lam joins the Surrealists.

1940–45
· Many European Surrealists live in exile in the USA and Mexico.

1942
· New York: 'First Papers of Surrealism', Whitelaw Reid Mansion

1943
· New York: 'Exhibition by 31 Women' at Peggy Guggenheim's gallery, Art of This Century. Featured works by Surrealists Dorothea Tanning, Leonora Carrington, Leonor Fini, Valentine Hugo, Meret Oppenheim, Kay Sage, Jacqueline Lamba Breton, Louise Nevelson, among others.

Mid-1940s
· Montreal, Quebec, Canada: Les Automatistes group is formed.

1945
· Budapest, Hungary: European School is formed.
· Malmö, Sweden: Imaginist group is formed.

1947
· Paris: 'Exposition internationale du surréalisme', Galerie Maeght, Paris

1948
· Barcelona, Spain: Dau al Set group is formed.

1959
· Paris: 'Exposition inteRnatiOnale du Surréalisme' (EROS), Galerie Daniel Cordier

1966
· Paris: Death of André Breton effectively ends the Surrealist movement.

INDEX OF SURREALISTS

PICTURE ACKNOWLEDGEMENTS

-

To Justin, Charlie and Cathy

-

Front cover: René Magritte, *Two Men with Derbies*, 1965 (detail). Gouache on paper, 25.4 x 31.8 cm (10 x 12½ in.). McNay Art Museum, San Antonio, Texas

Title page: Jacques-André Boiffard, *Sous le masque*, 1930 (detail from page 76). Centre Pompidou, Paris

Page 4: Wilhelm Freddie, *Les Tentations de Saint Antoine* 1939 (detail from page 42). Centre Pompidou, Paris

Chapter openers: page 8 Le Facteur Cheval, Le Palais Idéal, 1879–1912, Hauterives, France (detail from pages 28–9); **page 30** Jindřich Štyrský, *From My Diary*, 1933 (detail from pages 44–5). Trade Fair Palace, National Gallery of Prague, Prague; **page 68** André Breton, Valentine Hugo, Paul Éluard and Nusch Éluard, *Exquisite Corpse*, 1934 (detail from page 94). Musee d'art et d'histoire, Saint-Denis; **page 102** Woman sitting in Frederick Kiesler's *Multi-use Chair*, c.1942, Photo K. W. Herrmann. © 2019. Austrian Frederick and Lillian Kiesler Private Foundation; **page 136** Frederick Kiesler, Conceptual drawing for Salle Superstition, 1947 (detail from page 147), Philadelphia Museum of Art, Philadelphia, PA

Quotations: page 9 André Breton, 'Manifesto of Surrealism (1924)' in *Manifestoes of Surrealism*, trans. Richard Seaver and Helen R. Lane (Ann Arbor, MI, 1969); **page 31** Surrealist Group in England, *International Surrealist Bulletin/Bulletin International du Surréalisme*, no. 4, September 1936; **page 69** Salvador Dalí, in *Times-Dispatch*, 24 November 1940; **page 103** Eileen Agar, *A Look at My Life* (London, 1988), p.232; **page 158** (Jacqueline Lamba) from an interview with Arturo Schwarz in 1974, trans. Franklin Rosemont, excerpts in *Surrealist Women: An International Anthology*, ed. Penelope Rosemont (Austin, TX, 1998), p.77; (Luis Buñuel) Luis Buñuel, *Luis Buñuel: My Last Breath*, trans. Abigail Israel (London, 1984), p.123; (Conroy Maddox) Desmond Morris, *Lives of the Surrealists* (London, 2018), p.155; (Desmond Morris) Desmond Morris, *Lives of the Surrealists* (London, 2018), p.16; (Eileen Agar) Diana Hinds, 'Womb magic from an artist who teases', *Independent*, 28 September 1988